CHI

# Watercolour
# Innovations

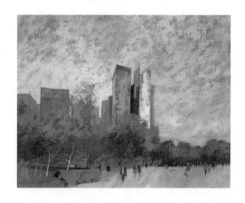

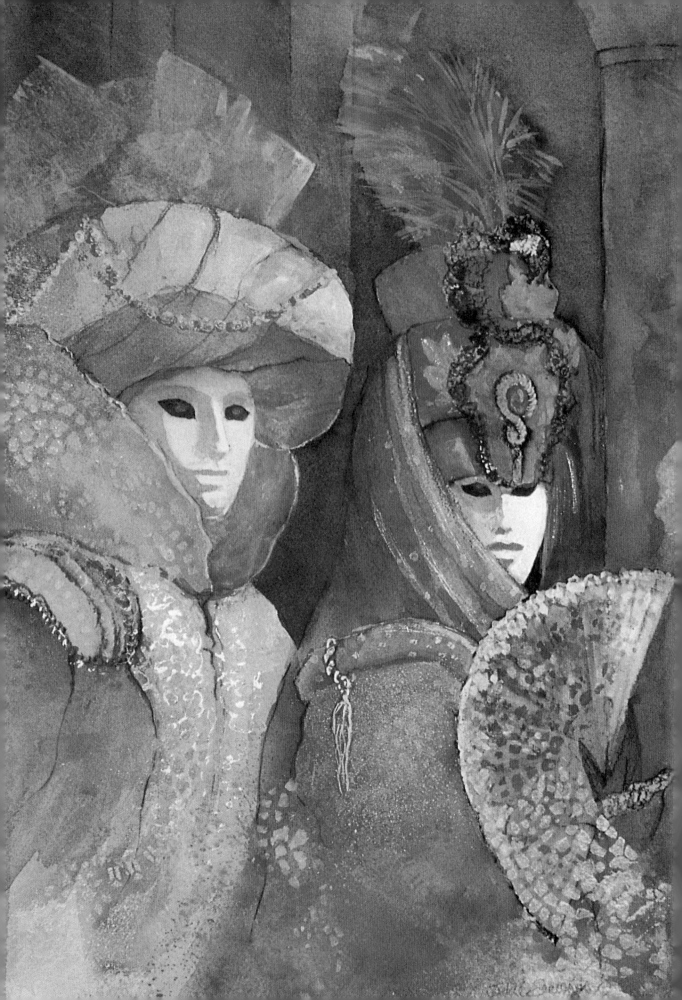

# Watercolour Innovations

## 8 TOP ARTISTS REVEAL THEIR STUDIO SECRETS

JACKIE SIMMONDS

**Collins**

**Acknowledgements**

With thanks to my long-suffering husband Geoffrey and both my daughters,
who support me unconditionally.

First published in 2005 by Collins,
an imprint of HarperCollinsPublishers
77-85 Fulham Palace Road, Hammersmith, London W6 8JB

The Collins website address is: www.collins.co.uk

Collins is a registered trademark of HarperCollins Publishers Limited.

09  08  07  06  05
6  5  4  3  2  1

**A catalogue record for this book is available from the British Library**

Editor: Geraldine Christy
Designer: Kathryn Gammon
Photographer: Patricia Rayner

ISBN 0 00 717782 8

Colour reproduction by Colourscan, Singapore
Printed and bound by L.E.G.O. SPA, Italy

Page 1: Terry McKivragan, **Shades of Autumn, New York**, 51 × 64 cm (20 × 25 in), acrylic on board
Page 2: Jackie Simmonds, **Red Carnevale**, 26 × 19 cm (10 × 7½ in), watercolour

# Contents

# Introduction

**'Without tradition, art is a flock of sheep without a shepherd. Without innovation, it is a corpse.'** Winston Churchill (1874–1965)

Pure watercolour is a member of a family of related painting media used for works that fall into the general category of 'watercolours' and fully accepted by institutions such as the Royal Institute of Painters in Watercolours and the Royal Watercolour Society in the UK, and the American Society of Painters in Water Color in the USA. Gouache, or 'body colour', is a form of watercolour in which the pigments are mixed with zinc white and are opaque in application. Yet another type of water-soluble pigment is the synthetic-polymer paint widely known as acrylic, which is available in both thick paint and liquid 'ink' form.

This book shows how eight talented artists use traditional and contemporary watercolour media with innovative methods in order to produce compelling paintings. Each has responded in his or her unique way to a certain spirit of adventure and, as a result, has found marvellous ways of strengthening both their work and their vision. These artists have generously shared their thoughts and ideas with me, and with you. I hope that the following pages will inspire and encourage you into a new world full of challenge and creativity.

You will find both figurative and abstract works here. You will probably relate to some, and not to others – that is natural. Remember that you can always learn something from others, even if their approach is one you would not choose for yourself. It is always good to have an open, enquiring mind – and to be prepared to enrich your life by increasing your knowledge and experience.

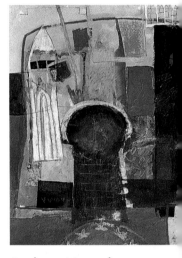

**Garden at Missenden Abbey**
**Laura Reiter**
55 × 38 cm (22 × 15 in)
Mixed media

*Laura worked at Missenden Abbey for a period and the architectural features of the ancient building and its colourful gardens provided the inspiration for this semi-abstract image created with layers of watercolours, acrylics, collage and oil pastel resist.*

# About this book

We begin our journey with a look at some of the techniques being used by innovative watercolourists today, followed by chapters that discuss the importance of dynamic design and expressive colour – important aspects in the process of the creation of a painting. These early chapters underpin the largest section of the book, the chapters that are devoted to the works of the talented artists who have shared their secrets with us.

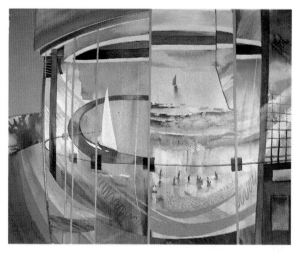

**View of St Ives**
**Richard Plincke**

38 × 50 cm (15 × 19 ½ in)
Watercolour and collage on
Saunders Waterford 190 gsm
(90 lb) paper

## Projects

There are several practical projects in the book. I hope you will find these not only fun to do, but that they will reinforce your knowledge and extend your experience. Spend a day or so experimenting with one or more of these projects; it will be enjoyable time profitably spent.

## Artist's secrets

Throughout the book are 'artist's secrets' – practical tips provided by the artists that offer insights and ideas you might never have otherwise considered.

## Analysed details

In the artists' chapters each painting has been analysed for you, mostly with the emphasis placed on the technique that has been used, although in some cases the design of the painting may be discussed. Understanding how a certain effect has been achieved can be really helpful when you are trying to further your own work. It is also fascinating to learn some of the reasons behind compositional decisions, and to discover that often there is nothing arbitrary about an artist's choice of colours or shapes. I hope you will begin to learn, from the examples offered, what it is that makes a painting particularly powerful and expressive.

**Presidential Palace, Havana**
**Terry McKivragan**

44 × 51 cm (17 ¼ × 20 in)
Acrylic on board

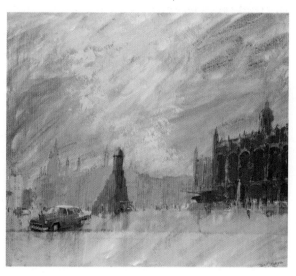

## Paintings in progress

Some of the artists have been kind enough to show their work as it develops. This is a chance to 'look over the shoulder' of a working painter and may help you to understand a little of the artist's thinking.

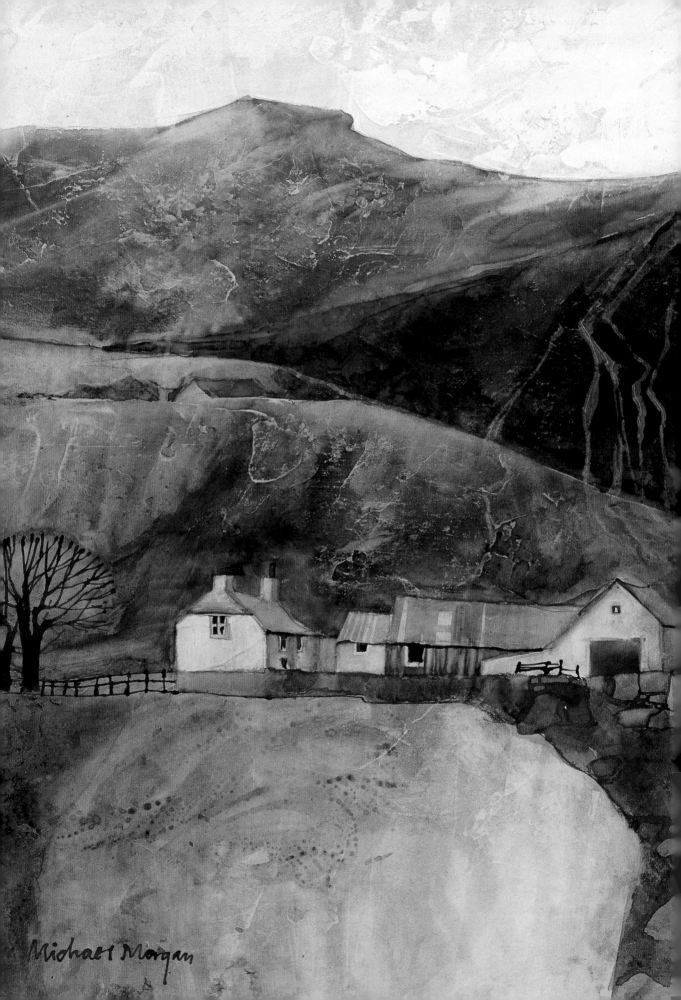
Michael Morgan

**Isolated Farm, Snowdonia**
Michael Morgan
$28 \times 43$ cm ($11 \times 17$ in)
Watercolour onto Fabriano
Classico 400 gsm (200 lb)
hot-pressed paper

# Techniques and skills

# Advanced techniques

**'The job of the artist is always to deepen the mystery.'**
Francis Bacon (1909–92)

The best way to equip yourself with a new vocabulary of exciting techniques is to give yourself permission to spend time experimenting with paints, brushes, papers, glue, sprays, tissue – anything and everything you can think of. Although this is a real treat, which I highly recommend as a 'tension-buster', it has a meaningful, serious purpose too.

## Materials

The main water-soluble media used by the artists in this book are transparent watercolour, gouache and acrylics.

*A typical selection of artist's brushes. Even old, worn brushes have a creative part to play for the inventive watermedia painter.*

### Transparent watercolour

Watercolour paint is available in pans, cakes and tubes, produced by a variety of manufacturers. It is graded as student quality or artist's quality, and the price varies accordingly. The price is also dictated according to the scarcity of the pigment and the manufacturing process. It is best to experiment with brands and colours. Pans are useful, particularly for the travelling painter, but it is easier to create a large puddle of pigment for a big wash using moist, juicy pigment squeezed from a tube.

## Gouache

Gouache consists of the same basic ingredients as watercolour, but with the addition of white pigments, which makes the paint opaque. The pigments may also be rather more coarsely ground. It is possible to dilute gouache to use it in a transparent manner, but when used thickly from the tube it is completely opaque. However, it is water-soluble even when dry and will lift when re-wetted.

The three tubes on the left are artist's quality gouache paint. On the right are bottles of acrylic 'ink' with rubber pipettes, and a tube of acrylic paint.

## Acrylics

Acrylic paint is a twentieth-century product. It consists of pigment bound by an emulsion of plastic resin, is available in tubes, jars and bottles, and varies in thickness and smoothness. Acrylics can be diluted with water to use in traditional transparent washes and can also be used thickly to give opaque results. However, unlike gouache, acrylic paint is completely waterproof, allowing for overpainting without any lifting of previous layers and making it perfect for transparent glazing techniques.

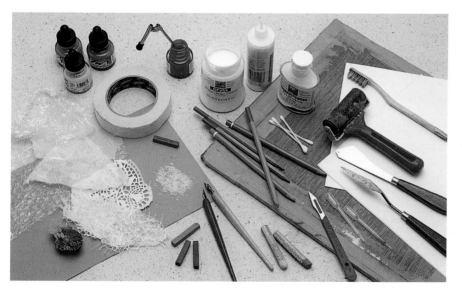

Here is a selection of additional materials for the specialist techniques that you will find in this book. They include media such as chalk pastels, wax crayons, pens and other mark-making tools for special effects, as well as masking fluid and tape, a hard rubber roller and PVA glue.

# Techniques

A really good painting is a superb combination of many elements – line, tone, form, colour, texture, design – and technique. Refining your technique skills is an essential part of the development of a painter, and the discipline of practice plays an important role in giving you the means to improvise with confidence in your paintings and to better express your creative inner vision.

It is a good idea to do these practice pieces in a watercolour sketchbook and keep it safe. In case you do not remember how you achieved a particular effect, make notes as you work.

Most of the technique examples below were painted on Not surface watercolour paper, unless stated otherwise. However, when you try out the following techniques, do try working on different watercolour surfaces – Not has a slight texture, rough has deeper indentations, and hot-pressed is very smooth. If you try papers from different manufacturers you will discover that they vary within these grades too; some have a surface that is far less absorbent, while others behave almost like blotting paper. Also try mountboard, either primed, or unprimed. The surface plays a large part in the effects you achieve.

**SALT TEXTURE**
Sprinkle chunky sea salt into a damp wash and leave it to dry thoroughly before brushing it off.

**ROLLER TEXTURE**
Pick up paint onto a small rubber roller from a large puddle of mixed colour and apply firmly to the paper. Use different sizes of roller for changes of scale in the marks and vary the direction of 'strokes'.

**BUBBLE WRAP TEXTURE**
Press bubble wrap into wet watercolour washes, lifting when dry. The effect can be increased with more layers of colour and more impressions of bubble wrap.

**COLOURED PENCIL WORK**
Use both the point and the sides of the pencil lead, overlaying different colours to achieve a varied effect. To create the impression of layers, work against a stencilled shape, such as a curve.

**CLINGFILM**
Lay a piece of clean clingfilm down onto a wet watercolour wash and push or pull the film around slightly to create directional lines. Leave it to dry thoroughly before lifting the film.

**MASKING**
For crisp edges (right) place low-tack masking tape onto the paper and then cut into shapes with a sharp knife. Overpaint, and lift off when the wash is dry. For smaller, more organic marks use masking fluid, which peels off easily by rubbing when it is quite dry.

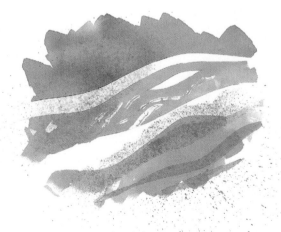

**SPATTERING**
Pick up paint on a toothbrush and, pointing the brush at the paper, run your thumb across the bristles towards you. This will 'flick' the paint away from you and onto the paper (left).

## COLLAGE

Tear horizontal strips from old paintings so that a white paper edge is visible. Stick them down with PVA glue and then cut small strips into geometric shapes and paste down over the top.

## TISSUE OVERLAYS

Apply torn pieces of tissue or Japanese textured papers to a sheet of watercolour paper using dilute PVA glue. When dry, overpaint with colour for soft, textural effects.

## OPAQUE OVER TRANSPARENT

Using a roller, apply watercolour over an initial watercolour wash. When both areas of watercolour are dry make marks with opaque gouache paint. Partially 'blot' the opaque marks with a tissue to lift some of the pigment and show the underneath colour.

## SPRAY PAINTING

Use a mouth diffuser or atomizer held in a bottle of liquid acrylic 'ink', and blow the colour through a stencil, paper doily, lace, or open-weave fabrics. Spray upright, and try not to tilt the bottle.

## GESSO UNDERPAINTING

Prepare the surface with two thin coats of acrylic gesso, then apply watercolour. Using clean water on a brush, lift out the colour while it is still damp to reveal the white underneath. Exaggerate the texture by spraying clean water onto the surface.

# PROJECT • Painting without a brush

**Although the brush is an indispensable tool for an artist working with wet media of any kind, and expressive brushstrokes are often an important and dynamic element of a painting, nevertheless it is easy to fall into the habit of repeating certain strokes and gestures to the point where monotony becomes a danger. It is worth experimenting with the idea of putting colour onto paper in different ways in order to supplement brushwork with unusual and rich surface effects.**

## Applying paint

Using either watercolour, gouache or acrylic paints, begin with thin areas of colour and, if you wish, add opaque colours gradually.

You can pour, dribble, flick, wipe, spray or flow paint onto the surface, and you can use any implement except a brush. Although a project like this can be playful, try to consider the design as you apply the paint. If your finished practice sheet does not work as a whole you may be able to crop several rather interesting small sections from it – they could be used as inspiration for further paintings.

After initial fun with pouring, sponging, flicking paint, and collage in the painting shown here, I applied a solid strip of opaque turquoise pigment to the top of the picture using a flat sponge on a stick. Immediately, I 'saw' a Mediterranean sky, with an old, textured, crumbly whitewashed wall below. I added some suggestions of foliage, grasses and flower heads. The straight lines were achieved with either the edge of a piece of card, or the chisel edge of the flat sponge. The circular dots of colour were applied with a cotton bud.

This image could be used as the starting point for another painting, incorporating many of the techniques you have discovered along the way, or it could even stand alone. Often a practice piece has an exciting, cutting-edge look to it.

**Mediterranean Wall**
**Jackie Simmonds**
25 × 20 cm (10 × 8 in)
Watercolour and acrylic on
Arches 640 gsm (300 lb)
Not paper

# Design dynamics

**'Composition is the art of arranging in a decorative manner the diverse elements at the painter's command to express his feelings.'**
Henri Matisse (1869–1954)

Good literature is more than just words. Organization, sentence structure and style all help to make or break a good story. In art the way the formal elements in a painting are arranged can make or break a good picture idea.

The artist who understands the importance of a strong design for a picture is an artist who has made the leap from the pure representation of objects – such as a jug, tree, or landscape scene – to someone who is truly beginning to 'see'. This artist is excited by the discovery of rhythms, shapes and connections that are perhaps not obvious at first glance.

There are no hard and fast rules for good design – only guidelines, and possibilities. Not every painter consciously decides before he or she begins exactly what will happen on the paper. Often you may make discoveries and changes as you create preliminary sketches, or even as the painting unfolds. However, a picture is made up of shapes, lines, tones and colours, and it is useful to think of each of these elements as an important force that helps to balance the composition. This chapter looks at some innovative design possibilities – not the basic ones, such as where to place a focal point, but those which I believe open the door to more powerful, expressive paintings. Discover relationships and rhythms that may have been invisible to you at one time, and may well be unnoticeable to someone who merely glances at the subject.

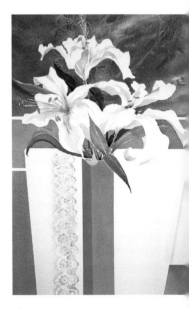

**The Orange Vase**
Jackie Devereux
54 × 38 cm (21 × 15 in)
Watercolour on paper

The unusually graphic quality of this still-life floral image has come about partly as a result of the interesting divisions of the rectangle. It is clear to see that the artist carefully considered the overall design of the piece.

# Linear movement

One of the forces that plays an important role in a balanced composition is 'linear movement', and you can think of directional lines or areas as supplying the underlying 'geometry' of your picture.

## Horizontal and vertical lines

A simple, static design can be developed from horizontal or vertical elements. A horizontal line implies quiet and repose, possibly because we associate a horizontal human body posture with rest or sleep. A vertical line, as in a standing figure, is also fairly static and is associated with strength and stability. In fact, horizontal and vertical lines within a composition are sometimes called 'stabilizers' – elements designed to reduce any feeling of movement. You can achieve balance and equilibrium in a picture by using these calming elements.

Horizontal and vertical forces imply stability.

## Diagonal lines

When the human body starts to move – walking, running, bending, swinging arms – the element of activity is introduced. Diagonal lines and forces in a painting suggest activity, and imply change, excitement or movement.

## Curving lines

Curving lines can be passive or active – a gently undulating, almost horizontal line is more passive than a maelstrom of swirling circles, for instance. These lines are often associated with the shape of the human body, but also with other organic forms such as plants, moving water and undulating landscape. Curvilinear marks are often joyful. If you were asked to represent 'joy', could you do this with vertical or horizontal lines? – I doubt it. Spirals, curves, arcs – yes. Straight lines – no; it just does not 'feel' right.

Diagonal forces give a heady feeling of tension, activity and excitement.

## Directions

An important function of lines within an image is to set up directions for the viewer to follow by giving the impression of 'pointing' in one way or another. Even disconnected lines, ones that are in different parts of the rectangle, may create a visual connection by virtue of being parallel, or at right angles to each other. A painter can enrich an image by orchestrating visual connections of this kind, and if you look carefully at paintings made by the Masters you will find frequent use of this artistic device.

Curvilinear forces give a feeling of movement. However, too many curves without some contrasting stabilizing force can be unsettling.

# Unity with variety

Without unity in a painting there may be visual chaos, and our minds and eyes are unhappy when faced with chaos. Unity, in the form of shape and pattern that is thoughtfully designed, is pleasing to the eye. You can achieve a sense of unity in a painting by the simple device of repeating elements. Repetition can be related to a fundamental element of the human life force – a heartbeat. The repetition of an element in a picture creates a visual heartbeat, or echo, providing a subconscious sense of unity and helping a complex design to 'hang together' in a harmonious way. Visual echoes strengthen the rhythm and movement in a painting.

Unity can be achieved by the repetition of colour, shapes, textures and linear directions. However, without some variety too many repeating elements can become boring. So, the artist needs to introduce some variation to relieve the monotony. For instance, the eye understands the repetition of arches in a bridge, finding order and harmony. But the irregular arches of a very old bridge are much more interesting to look at.

**A Way To Set Off Beauty**
**Laura Reiter**

61 × 46 cm (24 × 18 in)
*Mixed media on canvas*

In this image, inspired by Moroccan decoration, the blue pulls forward, while the maroon sinks behind – the strong contrasts give a sense of carved-out shapes. Squares and rectangles break up the rectangular format so that the repeated colours and shapes become strong formal compositional elements.

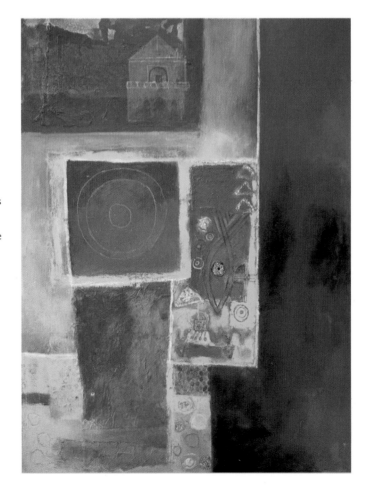

In my outline sketch of *Three Russian Dancers* by Edgar Degas (1834–1917) notice how the shapes within the group are similar, and how together they form one large shape within the rectangle. The four green background shapes are similar too, and the sky shape relates to the ground shape.

# Organizing shapes

Every part of a picture is, in fact, a shape. That shape might represent a cloud, tree or boat, but it is not a proper three-dimensional cloud or tree, or a real boat; it is a two-dimensional coloured shape with defined edges.

This concept is difficult to grasp, because there is nothing in nature that only has length and width, but no depth! Even a sheet of paper, which has the minutest degree of thickness, is a three-dimensional object. For a circle drawn on that surface – whether a coaster, an apple, or a balloon – to be anything but a two-dimensional shape you need to create, in your mind, the illusion of the third dimension of depth.

Once this idea is understood it is easier to see the importance of organizing echoing shapes. While a shape may be interesting in itself, it may not 'work' with other elements in the painting until it is adjusted to do so. An initial sketch of your subject gives you an opportunity to explore how to link or adjust shapes to create more rhythm and unity. This will act as a strong scaffold for your design.

In time as you look at any artwork you will start to discover subtle relationships between one shape and another. Echoing shapes will appear to vibrate with vitality, and visual patterns will emerge. You will become aware of groupings of shapes, and notice where they have been gathered together into large masses and how they contrast with each other.

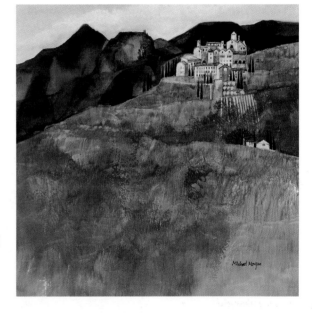

**Isola d'Elba Revisited**
**Michael Morgan**

37 × 37 cm (14 ½ × 14 ½ in)
Watercolour on Fabriano
Classico watercolour paper

The cluster of buildings form a triangle, which relates to the triangular shapes in the distant mountains. The rooftops echo, in reverse, the shape of the sky against the mountains. The three main divisions of the rectangle – sky, distant hills, and foreground – vary in size, but also have geometric shape similarities.

# Positive and negative shapes

A 'positive' shape is easy to understand – for instance, a chair is a positive shape. Even when we begin to use our greater understanding of shapes, in the two-dimensional sense, we can still 'see' the shape of that chair. A 'negative' shape is something quite different – it is that which is not your subject! It is, in fact, the spaces or shapes around your subject. In the case of a chair, it is the shapes between the chair legs, and between the rungs at the back of the chair.

What is even harder to 'see' is the negative shape between your subject and the edge of your picture. However, this, too, is an important shape. Failure to notice these negative shapes can mean that your subject is poorly placed within the rectangle, surrounded by unconsidered space, resulting in a lack of balance.

A simple way to think about negative and positive shapes is to imagine your finished painting as a jigsaw puzzle, with every shape within the border, both negative and positive, as a piece of the puzzle. The negative spaces in your picture are shapes in their own right – they have substance and mass. They define your subject. Considering, integrating and balancing both positive and negative shapes is, therefore, an important part of the picture-designing process.

Here are purple shapes (positive) painted onto a white ground, leaving white spaces (negative shapes). Or it could, in fact, be white shapes (positive), painted onto a purple ground (negative shapes). Positive and negative are equally important here.

**Spring Bouquet**
**Jackie Devereux**

72 × 53 cm (28 × 21 in)
Watercolour on Arches
300 gsm (140 lb) rough paper

Jackie has used the white of the paper as a strong 'negative space', dividing the image into slices in order to create an almost abstract, graphic effect. The lower area of negative white space contains a few 'fallen petals', positive shapes that activate a space that might otherwise have been rather stark.

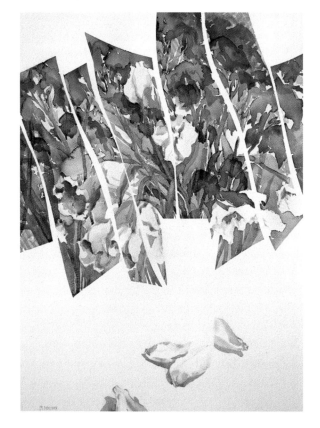

# Designing with tone values

We have discovered, so far, that subtle visual connections make for a strong underlying structure. While it is true that the success of a painting depends very much on these subtle 'hidden' elements, there is one obvious visual element that matters deeply too. That is the tonal design of an image – the distribution and balance of light, medium and dark shapes within the rectangle.

Passages of light, or dark, can move the viewer's eye through a painting, so the ability to manipulate areas of tone is a powerful design device. I emphasize the word 'areas' because tone values within an area can be simplified and brought even more closely together to become visually linked and thus create one large shape or area. In this way the areas of light, medium and dark tones within the rectangle become cohesive and strong.

### Dominant values

How tonal areas are distributed affects mood and feeling in a painting. But an important painting 'truth' is that equal quantities of almost anything can look boring. Thus, allowing one value to be dominant – be it light, medium or dark – always makes a more forceful statement. If dark tones dominate the picture they will give a dramatic or sombre effect, and a more 'closed-in', heavy feeling. If light tones dominate they will create a more open, lighthearted mood.

Notice how predominantly light tones within the rectangle create a very different atmosphere and feeling to mainly dark tones.

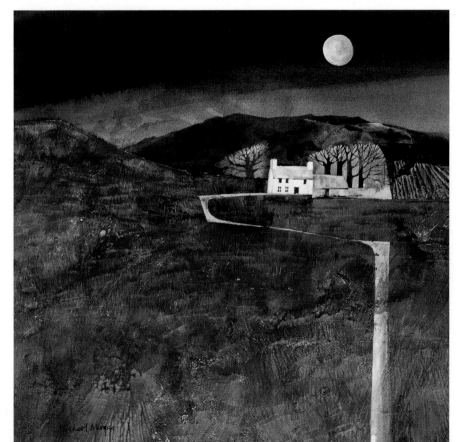

**Farm with Five Trees**
**Michael Morgan**

37 × 37 cm (14 ½ × 14 ½ in)
Watercolour on Fabriano Classico watercolour paper

This image has a sombre atmosphere as a result of the predominance of dark tones. The eye is pulled up through the light area of the path, to the house, and then up to the moon. This strong visual path would have been far less effective against large areas of light tone.

# Expressive colour

**'An avalanche of colour has no force. Colour attains its fullest expression only when it is organized, when it corresponds to the emotional intensity of the artist.'** Henri Matisse (1869–1954)

Colour is one of the artist's main design tools and every painting student eventually discovers the colour wheel and colour theory. The word 'theory' is not an appealing one – it implies study and learning, which can be daunting for some and irritating for others. Yet the more you learn about colour, the more you will discover the value of organizing colour deliberately.

There is also value in experimenting with interpretive colour – colour that more closely echoes your thoughts and feelings, rather than the literal colours you see before you. This, in turn, may well reinforce the expressiveness of your painting and emphasize the mood you want to evoke.

A willingness to let go of the desire to use only the colours you see before you can be very stimulating. Take a leap of faith, let go of convention and enjoy the freedom of using colour to reflect your feelings as a reaction to the subject, rather than as the camera might record it. This approach is not only challenging and exciting, but also marvellously liberating! While 'shape' and 'line' are intellectual concepts, colour touches the heart.

Colour stimulates the senses in a unique way and the artist who develops a sensitivity to the subtle, subconscious messages that colour can convey is adding dramatically to his or her arsenal of skills as a painter.

**Cliff Face**
**Richard Plincke**

71 × 53 cm (28 × 21 in)
Watercolour on Saunders
Waterford 190 gsm (90 lb)

This abstract piece earned its title as this theme began to suggest itself to the artist through the work. Richard often uses brilliant colour in his images, but not without careful consideration. In this instance, the dynamic colour, combined with jagged-edged shapes, adds to the exciting quality and atmosphere of the piece.

## Moroccan Town

**Ray Evans**

22 × 26 cm (9 × 10 in)
Acrylic on board

The use of subtle shades of
blue contrast with one area
of gold leaf, cleverly giving
the impression of white
buildings seen at dusk, with
just one small window
brightly illuminated by the
warmth of electric light as
evening approaches.

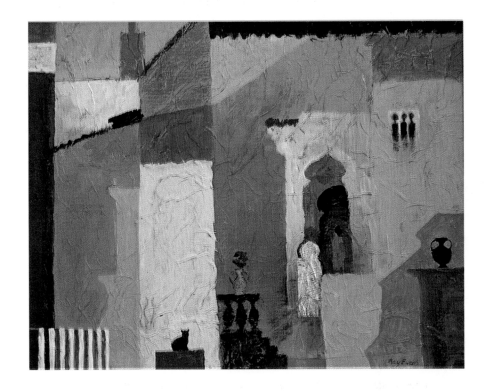

## Masks and Veils, Venice Carnival

**Jackie Simmonds**

51 × 56 cm (20 × 22 in)
Watercolour and collage on
Arches 640 gsm (300 lb)
Not paper

This image captures
something of the excitement
of the event and the 'colour
shock' of the Venice carnival
costumes, which illuminate
the scene as the revellers
stroll the streets.

# Colour theory

It is not vital to become an expert on the chemistry of colour, but studying some of the theory is interesting, and instructive. If you have not already done so, I suggest that you study at least a basic colour wheel, and make sure that you memorize which are the primary and secondary colours, and where they are situated on the colour wheel in relation to each other.

It is important to bear in mind, however, that paint colours vary from manufacturer to manufacturer and pigments do not all have the same strength or physical attributes. 'Artist's' colours vary, in some cases quite dramatically, from 'student's' colours, since the better quality paints contain more pigment and fewer additives or fillers. You need to experiment with paints, exploring colour mixtures and colour effects.

Experienced artists inevitably outgrow the simplifications of a colour wheel. Conscious planning and alternative paint choices will eventually be replaced by your own distinctive palette and instinctive mixing experience. As this happens, your ability to improvise and 'go with the flow' will increase as well.

## Colour harmony

One way to harness the expressive quality of colour is to choose to use colours adjacent to each other on the colour wheel. This will give you 'colour harmony' in your picture. The colour becomes a unifying force, knitting together all the shapes and forms in the painting. Your choice of colour, and the relative lightness, or darkness, of the tones you choose will greatly affect the atmosphere.

Some colour schemes are rich and vibrant. Others are more subdued and subtle. The choice of colour scheme is yours alone, and you should trust your instincts. Usually, if the colour 'feels' right for the subject, it will look right.

This is a very basic colour wheel, originally devised by Sir Isaac Newton. Red, yellow and blue are the three primary colours. Opposite each primary colour is its 'secondary', produced by mixing the other pair.

Each colour strip shows a set of colours that are alongside each other on the basic colour wheel. The deliberate choice of related adjoining colours helps to create a unified harmony in a painting.

# The impact of tone values

There is often confusion between 'colour' and 'tone values'. It is important to realize that every colour you use has a 'tone value' from light to dark. For instance, an Ultramarine Blue can vary, depending on the addition of water, or white, from a very light blue, to a strong, rich, dark blue. It is only the tone value that changes, however, not the actual hue. You may find it helpful to become familiar with how colour behaves and the various terms used to describe its behaviour.

Whatever the colour, tone is an essential consideration. Using extremes of tone in an image, from very light to very dark, can result in a visually strong image with plenty of drama and impact. When a closer tonal range is used, with little in the way of harsh contrasts, the image is likely to be more subtle and quiet. Thus, the expressiveness of the image can be affected by a good understanding of the impact of tone values.

**Blue Carnevale**
**Jackie Simmonds**

30 × 36 cm (12 × 14 in)
Watercolour on 300 gsm
(140 lb) Bockingford Not paper

This image is almost monochromatic, so the tones are immediately apparent. There is a wide range of tones, from white, through shades of blue, to very dark touches in places. The eye is drawn to the masks, partly because of their human characteristics, but also because of the strong contrasts of tone in those areas of the picture.

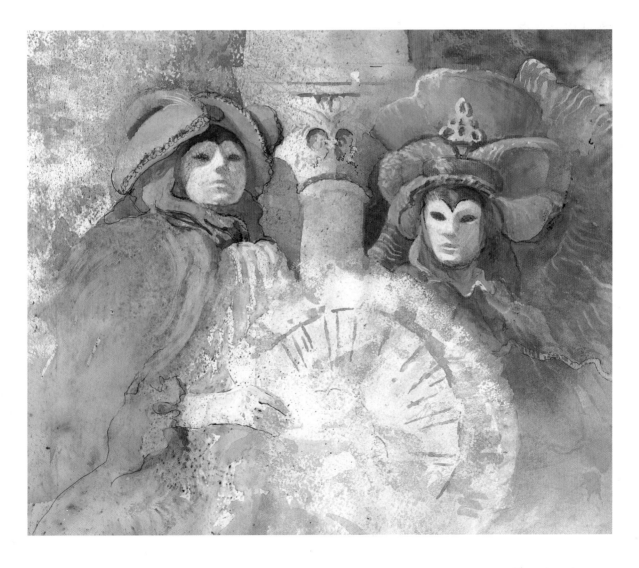

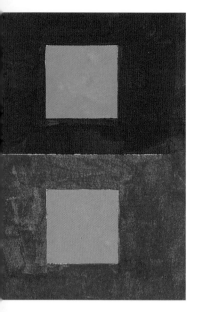

# Colour conflict

Colour 'conflict' is an important principle of colour theory employed by artists to give a painting unexpected dynamism. Colour 'opposites' can create tension by pushing and pulling against each other, energizing the picture surface and exciting the eye of the viewer.

'Opposites' are those colours on the colour wheel that are directly opposite each other. They are sometimes called 'colour complementaries', and can be used together to mix a range of subtle greenish, bluish or brownish 'coloured greys' that are quite unlike the greys achieved from a mix of black and white. Used unmixed, however, and placed alongside each other, these 'opposite' colours can create a strong, vibrant, visual sensation, an effect called 'simultaneous contrast', meaning that they each intensify the brilliance of the other.

It is strange, but true, that when the eye is exposed to a colour it seems to 'need' the presence of that colour's complementary to give some visual relief. There are scientific reasons for this, connected with the way that the eye and brain work together to define the external world. Red is a primary colour, green its complementary. So, a red passage in a painting will seem to create a greenish tinge to the colours near it. This kind of visual disturbance, or conflict, may not be immediately apparent to the untrained eye, but traditionally artists have used this phenomenon for impact. If harmony or tranquillity is the main aim it is advisable to avoid too much colour conflict in an image. On the other hand, colour conflict may often be used to add an element of drama or surprise.

As well as using colour complementaries for contrast and conflict in an image, artists also use colour contrasts of hue, tone and temperature. In this example, for instance, the central square is, in each case, the same colour, but its effect is dramatically changed by the temperature of the surrounding colour.

**Sainte Croix à L'Auze (II)**
**Richard Plincke**

38 × 72 cm (15 × 28¼ in)
Watercolour on Saunders
Waterford 300 gsm (140 lb)
Not paper

Richard's compositions often use strong tonal contrasts and colour conflict to draw the eye to certain areas. In this painting a kaleidoscope of colour works well; we are drawn to the central area of defined geometric shapes and primary colours, offset by blocks of neutral white.

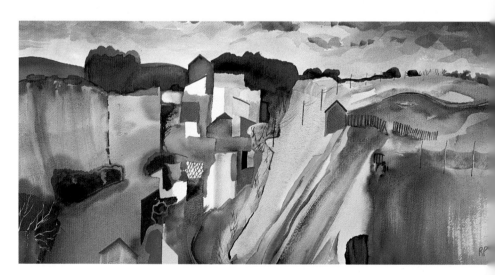

**Moroccan Village**
**Jackie Simmonds**

36 × 48 cm (14 × 19 in)
Watercolour, gouache and
pastel on board

This image has largely
expressive, rather than
observed, colour. I used yellows
and browns to warm the greys,
colour the sun-baked earth
and depict the softness of the
morning light with its promise
of heat to come. I altered the
colour of the sky to emphasize
the feeling I wanted to achieve.

# Colour in context

Every day we wake up to a world that is pulsating with colour. It is an integral part of our universe, affecting everything that we touch, eat, drink, use and are surrounded by. Clearly, colour has a profound effect on the human psyche, and this is perhaps why, for the artist, it is a most expressive element of design.

Through the ages colours have provided a means of reflecting status or attitude. Under Roman rule thousands of molluscs were used to produce enough dye for the Emperor's purple robes, so the colour purple represented power. For the Puritans, and in post-war Britain, the predominant colour for clothing was grey, associated with austerity and deprivation.

## Adjusting colour

While it is obviously useful to be able to reproduce 'local colour' – the colour that is present in nature – it is also possible to invent colours, and colour relationships, in order to explore mood and atmosphere. Responding to the 'pulse' of an idea may mean adjusting the colour. A palette with a warm bias will give an entirely different atmosphere in a painting to a palette with a cool bias.

A bright, high-key image will evoke a very different sensation to that of a dark, subdued image, which may have more of a moody, introspective feel. An artist has the ability to directly manipulate the emotions of the viewer through his or her choice of colour.

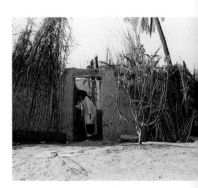

Notice from this original photograph how I have adjusted the colour for the painting. The 'local colour' was, in fact, a range of rather monotonous greys, barely warmed by a weak morning sun. The sky was a rather washed-out blue in reality.

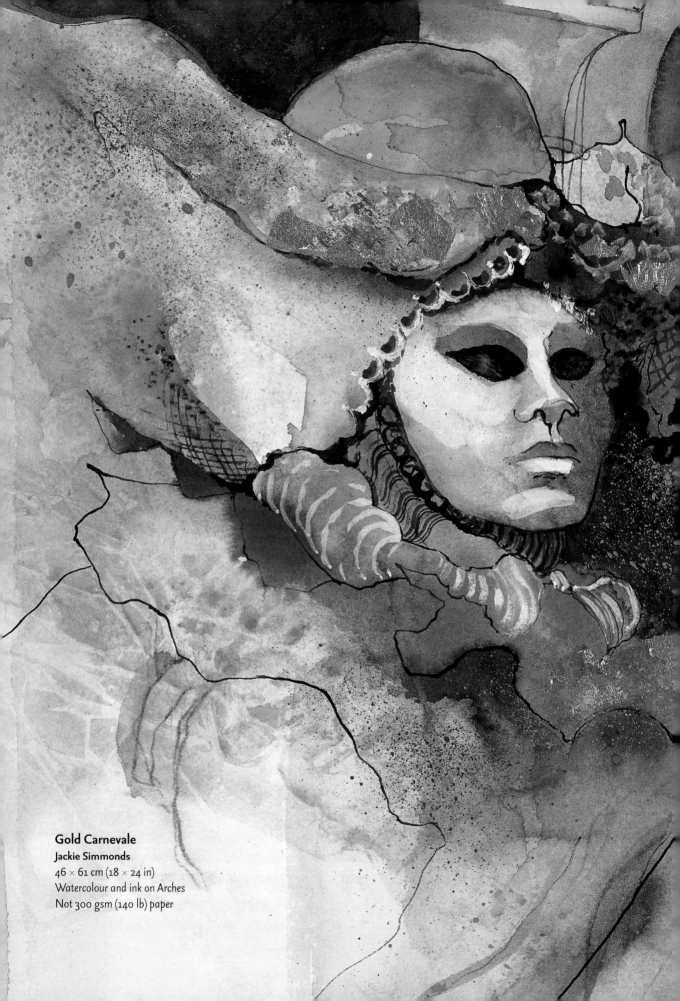

**Gold Carnevale**
Jackie Simmonds
46 × 61 cm (18 × 24 in)
Watercolour and ink on Arches
Not 300 gsm (140 lb) paper

A personal approach

# Drama
# and mood

## Michael Morgan

Michael Morgan is a watercolour artist whose distinctive work is in great demand by private and corporate collectors in the UK and abroad. After a career as a teacher and administrator in schools and higher education, he became a full-time painter in 1990, and in 1998 was awarded the Royal Institute of Painters in Watercolours medal for the most outstanding work by a non-member – followed subsequently by Membership of the Institute and the award of the Rowland Hilder Landscape Prize. He is a Founding Academician of The South West Academy of Fine and Applied Arts.

## The element of chance

Originally Michael worked in a traditional, representational way, but soon became frustrated with the inhibiting limitations of 'sticking to the rules'. So, he began systematically to explore more imaginative approaches to watercolour painting by visiting galleries and exhibitions, by studying the work of more adventurous artists, by reading avidly and by spending time experimenting. He has now developed an arsenal of innovative techniques that, when coupled with a unique personal vision and superb feeling for design, enable him to produce images that are compellingly imaginative and powerfully expressive. This vigorous, semi-abstract approach perfectly suits both his intellectual, analytical mind, and his emotional response to his subject matter.

Michael paints the drama and mood of the landscape. However, he never paints 'on site' – he does not even own an easel! He sketches, observes, and commits colours, shapes, textures and forms to memory, but then paints his landscapes back in his studio, as he wants them to be, rather than as they are. The idea of knowing beforehand what the picture is going to look like does not appeal to him at all. He feels there must be elements of chance – unexpected and magical – that have not been pre-planned.

## Materials and palette

Michael works with a variety of chisel-ended brushes, including 5 cm (2 in) decorator's brushes. He is not precious about brushes and does not feel the need for expensive sable ones, happily using nylon mixtures. He also uses plastic ice scrapers shaped for different purposes, plastic picnic knives, foam brushes, rubber colour shapers, hog-hair brushes, obsolete credit cards, crumpled clingfilm, greaseproof paper, blotting paper, dip pens, sharpened wooden sticks, his own fingers, a butcher's tray as a palette, and a hairdryer!

Michael's favourite surfaces are Fabriano Classico hot-pressed 400 gsm (200 lb) watercolour paper and Saunders Waterford hot-pressed 400 gsm (200 lb) watercolour paper. He also works on sheets of acid-free mountboard, which are sometimes partly primed with acrylic gesso, leaving random, untouched areas of board that will react quite differently to the paint.

**Michael's palette includes:**

Raw Sienna

Burnt Sienna

Indigo

Phthalo Blue

Raw Umber

Aureolin

Cadmium Red

Brown Madder Alizarin

Michael occasionally uses Cadmium Orange, Quinacridone Gold, Hooker's Green Dark or Phthalo Green, to make a particular statement.

Michael Morgan prefers to work in his studio, at a desk rather than at an easel, which gives him greater freedom of movement.

Michael uses sketchbooks to explore compositional ideas, and to experiment with colour studies and techniques. His sketchbooks provide a wealth of inspiration.

# Techniques

The artists in this book have extended their arsenal of techniques in order to express themselves in a more interesting and varied way. The traditional watercolourist will master basic techniques – working wet-on-dry and wet-into-wet, learning how to maintain transparency with crystal washes and how to avoid 'mud' when mixing and layering. The ability to control the medium perfectly is important. An experimental watercolourist, or water-media painter, however, is prepared to move right outside his or her comfort zone in a spirit of adventure and creativity. Michael Morgan creates a wealth of texture and interesting effects by combining watercolour with gesso and gel retarder, and using a variety of mark-making implements.

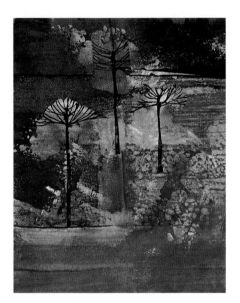

**GESSO UNDERPAINTING**
Acrylic gesso was first randomly applied to hot-pressed watercolour paper, then strong concentrated watercolour washes stroked across the surface. Where there was no gesso the watercolour sank into and stained the paper, remaining strong and dark. The gesso, however, resisted some of the pigment, and those areas remained lighter. The trees were drawn with a pen and a strong mix of pigment.

**SANDING FOR ALTERNATE SURFACE**
Watercolour washes were painted onto a gesso-primed board. When dry, some areas were sandpapered to provide different surfaces to work on. A pen dipped in water was used to draw into the surface, and then the colour was removed with blotting paper.

## WATER SPRAY

Gesso underpainting on mountboard was sandpapered in places and painted with watercolour washes. Once dry, texture was created with fingers dampened with water and also water spray. Lines were drawn with the sharpened end of a paintbrush dipped in water, and then blotted out.

## INCISING

A piece of acid-free mountboard was partially painted with gesso. A mixture of Green Gold and a little Indigo was painted over the top. The lines were drawn into the wet pigment with a plastic scoop cut into a knife shape. At the bottom, water sprayed onto the pigment created a texture.

## THICKENING MEDIA

Acrylic gesso was painted onto 400 gsm (200 lb) Fabriano Classico hot-pressed paper and allowed to dry. Impasto gel was mixed with the watercolour, and a palette knife was 'pulled through' the thickened paint, separating the colour and creating line work.

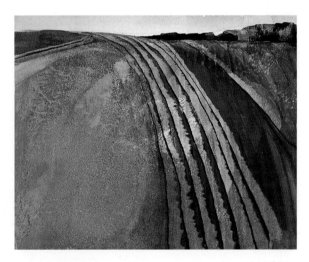

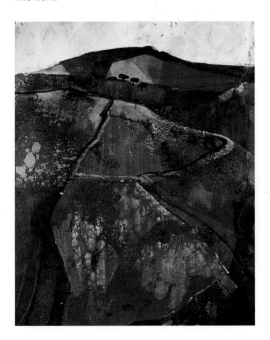

## GEL RETARDER

Some acrylic gesso was painted onto hot-pressed paper, and sandpapered when dry for a smooth finish. Watercolour washes were applied, then greaseproof paper was pressed onto the surface. More watercolour was mixed with acrylic gel retarder and painted on; before it dried, a palette knife was used in a sideways motion to create the 'ploughed field' lines.

# Coastal Farm

Restrained colour and subtle flowing lines throughout hold this painting beautifully in balance. We move into it from the lower half, our eye drawn up by the dragged lines that suggest the ruts in a partly ploughed field. Having lingered for a while to study the farm buildings, the eye is pulled once again from the trees, via a dark, gently curving form, up into the middle distance. Then a subtle curving line, carved into the honey-coloured wash, takes us to the coastal area, around the bay and into the hills beyond. These graceful curves, echoing arcs and oval shape areas are vitally important to the composition.

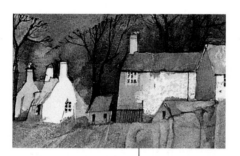

There are two ways to create small, brilliant areas of pure white without painstakingly painting 'around' the shape. Use masking fluid on the virgin white of the paper, and carefully remove it after subsequent washes have dried, or use body colour – Chinese White watercolour, white gouache, or white acrylic – to paint the shape.

**Coastal Farm**

**Michael Morgan**

35 × 35 cm (14 × 14 in)
Watercolour on Saunders
Waterford 400 gsm (200 lb)
hot-pressed paper

The addition of acrylic retarder gel to stiff watercolour pigment created a viscous pigment, which remained wet and allowed prolonged work. Here, the thick pigment was separated out with the edge of a palette knife to give the impression of ploughed lines.

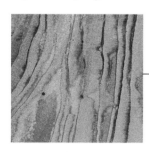

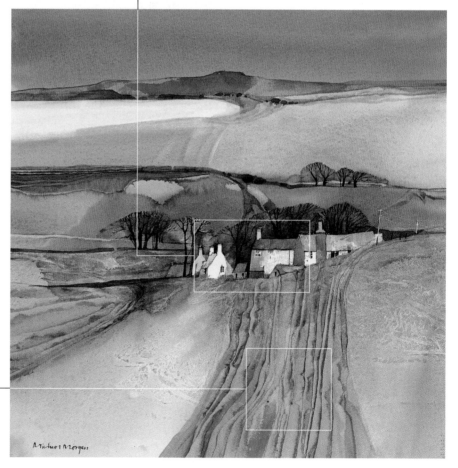

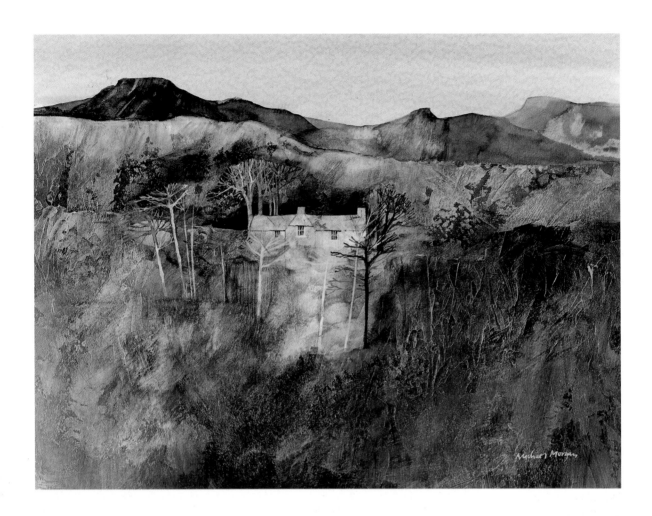

# Winter Morning One

Shattered scree on mountain slopes; frost whitely glistening on tree trunks and branches in the strange, magical light of a weak winter sun – winter's spidery textures and subtle, almost monochrome colours are uniquely beautiful, so very different to the lush rich colours of other seasons. Also, at other times of the year the land is bursting with goodness, and the birds celebrate this bounty with song. For the country dweller, birdsong and insect 'chatter' produce a continuous background symphony. With the onset of winter, however, the land becomes quieter, particularly when snow and ice blanket the earth, so muffling the sounds of nature.

The artist has recognized the power in the expressive qualities of colour, and has cleverly emphasized the quiet atmosphere of winter by keeping to a very limited and carefully selected low-key palette, with the use of subtle, close tones. As a result, the feeling of the cold, dormant quality and silence of winter has been captured to perfection in this haunting image.

**Winter Morning One**
**Michael Morgan**

30 × 39 cm (12 × 15 ½ in)
Watercolour on Saunders
Waterford 400 gsm (200 lb)
hot-pressed paper

# Coastal Hamlet

This painting is a powerfully evocative mixture of stylized forms and organic textures. It conveys the feeling of a time and a place of the artist's own creation, culled from memories and embellished by imagination. The collection of clean, crisp white buildings, bathed in a golden glow, is a shock of brilliant light in an otherwise warmly mellow landscape. Are the buildings moonlit, since the sky is so dark? Or, perhaps, this is one of those magical moments when, as the sky dramatically darkens with the onset of a storm, one final shaft of sunlight strikes the land. Michael was once told that there is often a paradox in his pictures – they are accessible, yet demanding; familiar, yet unusual. Here, the buildings are snugly enfolded by sinuous lines sculpted out of the landscape; we are drawn like a magnet to them, and then to the suggestion of coastline.

**Coastal Hamlet**

**Michael Morgan**

53 × 51 cm (21 × 20 in)
Watercolour on Fabriano
Classico 400 gsm (200 lb)
hot-pressed paper

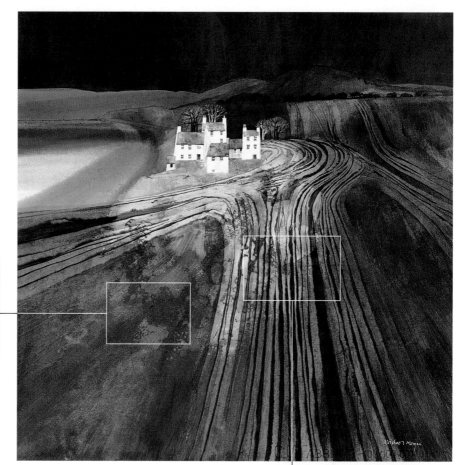

You can see clearly where paint applied to gessoed areas remained fairly transparent, while the bare mountboard absorbed the wash, providing areas of rich darkness. This depth and variety of texture and colour can be achieved with no more than two or three washes, provided that the brush is well charged with rich colour.

These 'ploughed lines', created by the use of a palette knife pulled through pigment thickened with acrylic retarder, were the last marks on the surface. The previous layers of gesso and watercolour pigment show through where the paint was dragged to one side, adding to the texture and variety of the marks.

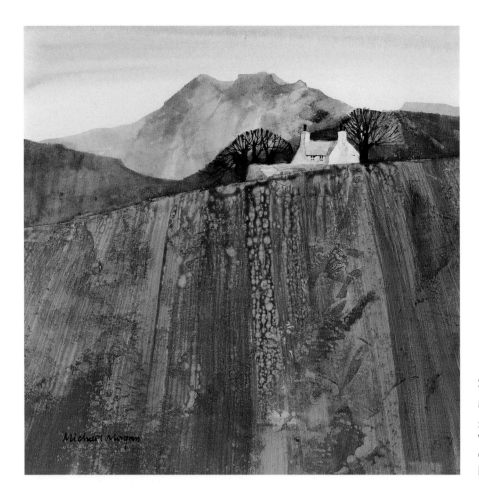

**Solitude One**

**Michael Morgan**

24 × 24 cm (9 ½ × 9 ½ in)
Watercolour on Fabriano
Classico 400 gsm (200 lb)
hot-pressed paper

## Solitude One

About 80 per cent of the land of Wales is used for farming. Amongst the
u-shaped valleys, craggy cliff faces and still, smooth lakes scooped out by
glaciers are little farms surrounded by vast empty fields and windswept trees.
The buildings often seem to echo shapes in the surrounding landscape, almost
as if born to the landscape rather than having been built. On his travels Michael
often pulls into a lay-by, and sits, contemplating and memorizing the scene.
This painting has the feeling of just such a remembered place.

It is the combination of gesso and paint that does most of the work in the
image. The gesso was applied with a flexible spatula, then a wash of strong
watercolour was painted with a very wide brush, pulling the paint down towards
the base of the picture. As it dried so textures appeared. Further applications of
paint deepened the colour as it granulated in some areas and stained any
portion of the board not covered with gesso.

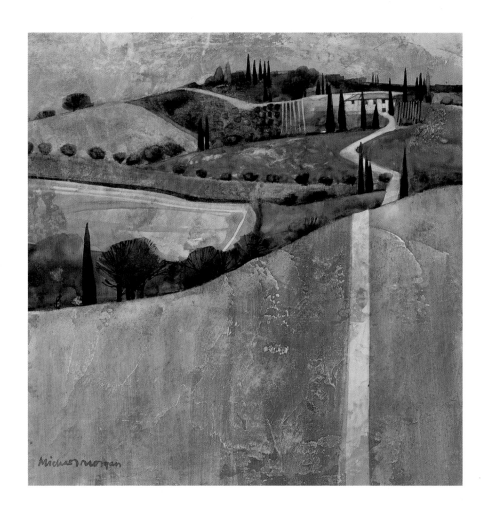

**Tuscany Path**

**Michael Morgan**

20 × 20 cm (8 × 8 in)
Watercolour on Saunders
Waterford 400 gsm (200 lb)
hot-pressed paper

## Tuscany Path

Michael sometimes begins by painting unstructured, organic abstract colour areas, and then allows the image to reveal itself to him by connecting with his memories. In this case the picture was actually started upside down. However, when he turned the painting the other way, the colours and shapes seemed very appropriate for a warm Tuscan sky, and the picture was developed from there. The golden tones in this painting evoke the warmth of this beautiful corner of Italy.

Over a gessoed ground, transparent areas of pink, gold and soft purple were gently rubbed with a finger to give a feeling of warm summer sky and sun-kissed clouds. The texture in the foreground was achieved by painting layers of pigment with a wide brush, again over a previously gessoed surface. Pigment does not adhere well to gesso, and so several layers needed to be applied. This technique takes some practice and, according to Michael, it can cause a certain amount of frustration to achieve this depth of colour.

# Tuscany Two Revisited

There is a sense of timelessness and moody silence in this image, the vertical compositional elements helping to evoke a powerful sense of atmosphere. The underlying geometry of an image always plays a huge part in reinforcing its expressive message. In design terms, horizontal or vertical elements within an image are solid and stable, implying balance and equilibrium. They are static, and calm, providing 'punctuation marks' and rest areas that halt the eye.

The flattened perspective, the stylized shapes, the colour, the choice of geometric design and the innovative techniques all combine to create a strong image. The artist worked on mountboard partly primed with gesso, and the gessoed areas provided a far less absorbent surface that was more responsive to colour-lifting techniques and textural effects.

**Tuscany Two Revisited**
**Michael Morgan**
27 × 23 cm (10 ½ × 9 in)
Watercolour on acid-free
mountboard

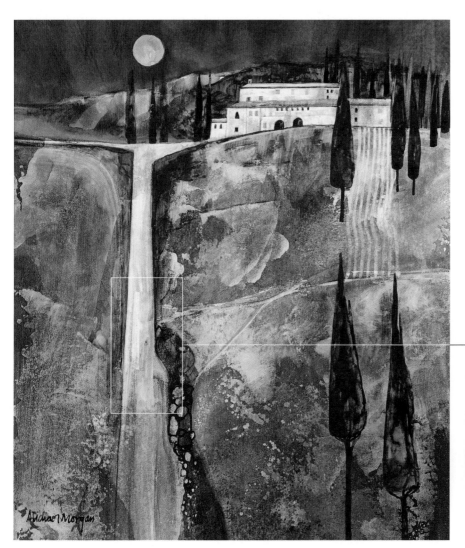

To achieve the light area of road, clear water was applied to the board, and the watercolour dragged off with a brush. More pigment was removed from the top half of the road than the bottom half, forcing the eye to travel up towards the moon and the Tuscan villa in the landscape.

# Near Blaenau Ffestiniog

This area of Wales once boasted the biggest slate mines in the world. Although they are no longer working mines, tourists can visit them, and travel down the steep railway into the dramatic chambers of the Deep Mine. At the nearby Gloddfa Ganol Slate Mine it is possible to visit 42 miles of tunnels and slate quarries. Michael has captured both the drama and the feeling of this brooding, unusual landscape, with a semi-abstract interpretation, fusing powerful inner vision with exciting composition and innovative painting techniques.

As already mentioned, angular shapes and lines within the underlying geometry of an image can provide a syncopated rhythm, which activates the composition in a dramatic, exciting way. In this image, dynamic geometric angular shapes slice through rich dark-veined areas that are strongly redolent of sharp-edged, jagged, layered sheets of blue-grey slate. The result is visually active, and rather disturbing, echoing this bleak and violated landscape ripped asunder by the hand of man.

Tiny parallel lines of pigment were created with 'dry-brush' painting, using a decorator's bristle brush that had been given a haircut! Michael 'chopped' into the end of it to thin the bristles. This gave him a brush that makes a different kind of mark, often also used for stippling.

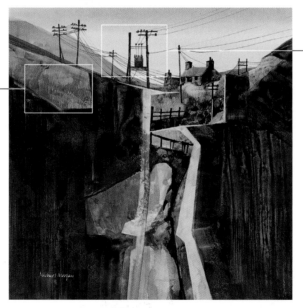

The sweeping telegraph lines were achieved with a dip pen loaded with paint. Notice how the lines vary in strength and weight. It is not possible to create them like this with a technical pen – this effect can only be achieved with the flexibility offered by an old-fashioned nib.

**Near Blaenau Ffestiniog**
**Michael Morgan**
*32 × 32 cm (12 ½ × 12 ½ in)*
*Watercolour on Saunders*
*Waterford 400 gsm (200 lb)*
*hot-pressed paper*

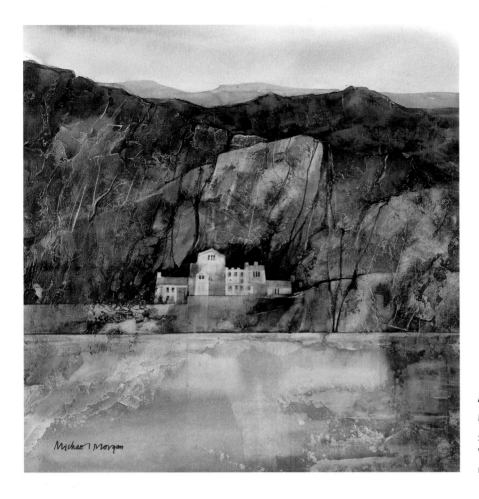

**Abandoned Priory**
**Michael Morgan**
29 × 29 cm (11 ½ × 11 ½ in)
Watercolour on acid-free
mountboard

# Abandoned Priory

This scene of an old priory at the edge of a lake is entirely imagined. The hills behind enfold the ancient, beautiful building, and lines of colour bleed down the towering escarpment. Subtle warm and cool colours melt into each other, and textures abound. The shape of the priory is defined by the darkness behind it. Dark pigment was painted into this area, and pulled into adjoining areas with a sharpened wooden implement. The abstract qualities of the paint surface add to the mysterious atmosphere; the turbulent marks – a combination of 'unexpected happenings' and exaggerated linear strokes – contrast powerfully with the simple structural forms of the building and the horizontal shape of the lake below, creating tension within the image.

'Unexpected happenings' may occur in all of Michael's works, but their success does not rely on a haphazard approach. He clearly organizes his ideas into powerful compositions, and beneath the wonderful textures, forms and shapes, there is always a firm foundation of strong design.

# Transparency and texture

## Jackie Devereux

Jackie Devereux's early career as a freelance illustrator and calligrapher has been supplanted by working as a full-time professional painter and teacher from her home in the South of France. Jackie has exhibited in the USA and Japan, and holds regular one-person exhibitions of her paintings in France and the UK. It is hardly surprising that her work is attracting international attention since she has won major prizes in recent years. Jackie's speciality is carefully constructed, luminous watercolour paintings that intriguingly use large areas of white paper, collage and embossing, along with traditional layering techniques.

## Luminous watercolours

Jackie is unashamedly obsessed with the quality of crisp white tablecloths, glass vases and flowers. Her pictures often contain architectural fragments, or parts of landscapes, suffused with the warm golden light of the South of France. It was the sometimes-unbearable heat of the Mediterranean climate that first drove Jackie to seek refuge from the sun's scorching rays, but the cool quiet of her studio allows free rein for her imagination.

Sometimes an outdoor sketch is a starting point; at other times, part of a still-life set-up sparks ideas. She spends a considerable amount of time looking and thinking about each phase of a painting, but likes to work swiftly in order to prevent overworking. She works to a large format to have more freedom for

large white spaces, and to pursue the graphic quality that she loves. Jackie's art is a mix of the real and the dream-like, created with luscious transparent watercolours that are manipulated to make what is, eventually, a kind of collage of effects. Whatever her choice of subject matter, the brilliant light and jewel colours of the part of the world she has made her home are an important part of her paintings.

## Materials and palette

Jackie uses a wide range of colours, and she is very conscious of the relative transparent or opaque qualities of the tube colours she uses. She likes to use a brush with a good bowl and fine point, and finds that the range of Petit Gris in various sizes suits her approach. She also likes to have a good sable rigger and a fair-sized wash brush to hand.

Jackie's preferred support is Arches 300 gsm (140 lb) rough watercolour paper, which she always stretches onto a board. She uses Arches 300 gsm (140 lb) linen for more detailed works, and Montval 300 gsm (140 lb) paper for working with pen dipped into watercolour, and watercolour wash.

Jackie uses stencils, a craft knife and a bookbinder's bone for hand-embossing.

For embossing Jackie works on a lightbox, pressing into the paper, which is laid on top of the cut stencil, to make a raised image.

**Jackie's palette includes:**

Aureolin (transparent)

Cadmium Yellow Pale (opaque)

Naples Yellow (opaque)

Raw Sienna (transparent)

Burnt Sienna (transparent)

Manganese Blue (transparent)

Coeruleum (opaque)

French Ultramarine (transparent)

Indigo (transparent)

Winsor Blue Green Shade (transparent)

Winsor Violet (transparent)

Viridian (transparent)

Bright Red (opaque)

Scarlet Lake (transparent)

Permanent Rose (transparent)

Alizarin Crimson (transparent)

Jackie sometimes, but rarely, uses Raw Umber and the only tube green she buys is Viridian, which she finds useful for mixes.

# Techniques

Jackie's paintings often depend for their success not only on large areas of white paper to offset the coloured areas, but also upon well-crafted techniques within the watercolour passages – techniques that are carefully controlled and used thoughtfully to enhance the image. When she uses any unusual techniques Jackie ensures that the effect is subtle and does not overwhelm the image. Always, the demands of composition and design take precedence over technique, which is used to support these more important painterly considerations.

**MASKING FLUID**
Masking fluid was applied first with a ruling pen, and allowed to dry. Then a layer of blue watercolour was washed over and also left to dry. Subsequently, the masking fluid was removed and further transparent washes were applied.

**ROLLER TEXTURE**
A sponge roller was coated with blue watercolour, and then with green, before being applied to dry paper. While the stripes were still damp, pink and yellow washes were brushed over the roller marks. Kitchen paper was used to remove excess paint from the roller, and a further impression made by laying the sponge roller face down and rolling over it with a hard rubber roller.

**MASKING TAPE**
Thin cut strips of low-tack masking tape were placed at random on dry paper, and then the flowers were painted directly over the tape. When the watercolour was dry the tape was lifted, leaving bright, white stripes.

### CLINGFILM

Delicate washes of transparent colours were floated wet-into-wet across the paper, before applying clingfilm, which was dragged across to encourage the colours to merge. The watercolour was allowed to dry completely before the removal of the clingfilm.

### CREATING LINES

A strong mix of green watercolour was washed onto dry paper, and then a wash of violet was allowed to merge with it. While the washes were still very wet, a five-pronged ruling pen was pressed hard onto the paper, creating dark lines where the prongs scored the surface.

### PAPER IMPRESSION

This is an impression taken from kitchen paper, on which Jackie had 'cleaned' the sponge roller after using it to apply colour. She then placed the kitchen paper onto watercolour paper, and rolled over it with a hard rubber roller.

### PAPER STENCIL

Watery blue washes were applied and left to dry. Then a watercolour paper cut-out was generously wetted with colour using a sponge roller, and 'printed' onto the dried surface. This 'stencil' was placed face down, covered with a piece of kitchen paper and firmly rolled with a hard rubber roller. The process was repeated with blue and red. Mottling was created with a sponge roller and by lifting off some of the wet pigment with a tissue.

### HAND EMBOSSING

A light wash of blue was applied and, when almost dry, clear water was dropped onto it, creating a 'cauliflower' effect. When this was also dry two areas of green were brushed on, with subsequent lines delicately overlaid to give the impression of greater depth. Finally, an area of embossing was created; this is most visible in the white, or lightest, areas.

# Painting in progress

This painting gives an insight into the process of producing an image with hand-embossed panels. To create an embossed area Jackie cuts a stencil from 300 gsm (140 lb) paper or card, then places the shape, image side down, under a sheet of watercolour paper. With a blunt smooth implement, such as a knitting needle or bookbinder's bone, she presses very firmly into the paper against each cut edge of the stencil, creating an embossed, or raised, image.

**Step 1**

The pencil sketch was not an accurate preliminary sketch that was then copied – it was more a collection of thoughts, many of which were introduced as the work progressed.

**Step 2**

Jackie used masking fluid to give the 'lace' effect, and masking tape to retain crisp white edges and areas. The texture on the jug was created with a sponge roller. Several washes were overlaid, then clingfilm dragged across for texture. The removal of the masking fluid 'revealed' the lace, seen in the blue area.

**Step 3**

There was a gradual build-up of layers of carefully selected transparent colours. Large areas of white were left unpainted.

**Step 4**

This final stage shows yet more layering of delicate washes, and the addition of hand-embossed panels, giving the impression of hidden depths.

**Composition with Orchid**

**Jackie Devereux**

46 × 61 cm (18 × 24 in)
Watercolour on Arches 300 gsm (140 lb) rough paper

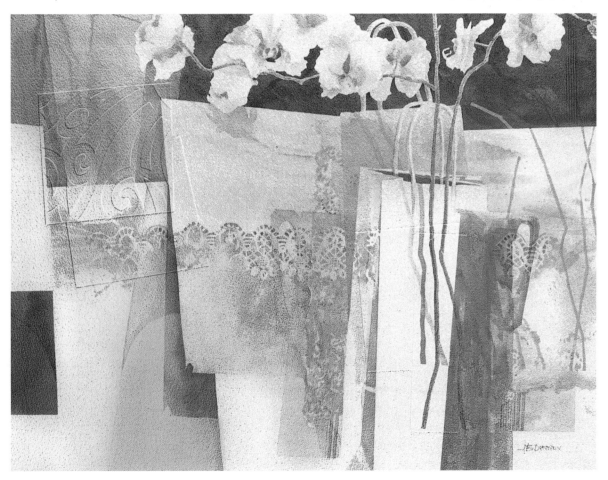

# Yellow Vase

An oncoming autumn storm forced Jackie indoors to paint. The threatening clouds on the horizon were dark and dramatic, and remained in the artist's conscious mind as she set up an indoor still life. So, she decided to include them, together with some suggestion of distant landscape. It is often difficult to design a painting that combines both still-life and landscape elements because of the disparities of scale and the differences in the relationships of the shapes. However, if it is carefully considered and planned it can be most effective, resulting in a still-life composition of unusual character and great interest. It is particularly interesting to see how the carefully orchestrated large white areas, untouched by pigment, add to the complexity and drama of the image.

Wet-into-wet glazes were carefully controlled for the dramatic cloud effect – the blue was dropped onto the red wash and allowed to spread only so far. Understanding how wet a previous wash needs to be, and how much pigment can be further added without creating nasty tidemarks, is a skill that comes from much practice.

**Yellow Vase**

**Jackie Devereux**

52 × 72 cm (20 × 28 in)
Watercolour on Arches
300 gsm (140 lb) rough paper

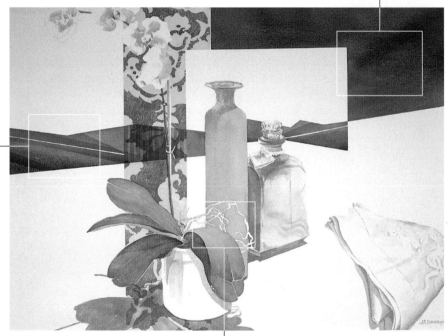

Masking tape was used for the graphic rendering of sharp edges. It is easy to cut or tear the tape to give the desired shapes. To avoid leakage under the tape, however, always make sure it is firmly stuck down, and brush away from its edges.

The white lines of the plant, against the yellow of the vase, were created with masking fluid. When using masking fluid make sure that it is fairly fresh, and remove any skin or lumps that may have formed around the edge of the bottle.

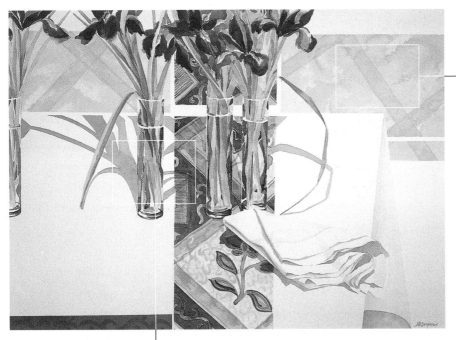

The orange border behind the flowers was painted with wet-into-wet washes, allowing tidemarks to develop and energize the wash. The diagonal stripes were painted over the top when the first wash had dried.

A transparent blue glaze suggests shadows. The patterned area was painted first and left to dry thoroughly before shadows were applied. Retaining the transparency of a shadow is a fine art – opaque colours need to be applied first, with transparent colours over the top.

**Irises and Tumblers**

**Jackie Devereux**

51 × 71 cm (20 × 28 in)
Watercolour on Arches
300 gsm (140 lb) rough paper

## Irises and Tumblers

A row of tumblers filled with irises makes another unusual subject for a painting when combined with large areas of white paper and a variety of interesting flat, geometric shapes that suggest fabric. This image proves that it is not necessary to use elaborate vases or jugs when painting flowers – simple containers can look just as effective.

Jackie employed a straightforward approach for this painting, using transparent glazes of colour and applying them carefully to take account of the dryness, or wetness, of previously applied colours. It is the unpredictability of the composition that is of most interest – the cropping of the flowers at the top of the composition, for instance, is brave and unusual. Notice also the bold use of red in the horizontal band on the left at the base of the painting, echoed by tiny touches of red elsewhere. See how many echoing diagonals and diamond shapes you can find throughout the piece, too.

## Artist's Secret

For clear, luminous washes:
• Always keep your palette as clean as possible, paying particular attention to the corners of square mixing areas.
• Use plenty of water for mixing. Always use two jars – one for an initial rinse, and another for a final rinse.
• Either work wet-into-wet, or wet over absolutely bone-dry washes.

# Lillies – Fragments II

This painting began its life as a demonstration of a painting of lilies. Jackie felt that the finished piece was not quite good enough to be framed, so she chopped it into pieces to use for a hand-made greetings card. She then decided to use the card as inspiration for a large painting. Jackie found this a wonderful creative experience, a very accessible way of discovering how to create an image that has an interesting combination of abstract shapes and recognizable figurative elements. It taught her a great deal about reserving the white of the paper, and treating the resulting 'negative' shapes as an important part of the image – painting, if you like, without actually painting!

It is vitally important to recognize that even an unpainted area of white paper has to be carefully considered as a strong element of the composition, and has as much to contribute as a coloured area.

The layers in this background shape were created with a combination of glazes, using masking tape for the crisp edges and masking fluid over the initial 'red' wash so that the light shapes would remain untouched by the subsequent transparent blue wash.

The white lace was created by painting the blue shadows, which then revealed and described the lace pattern.

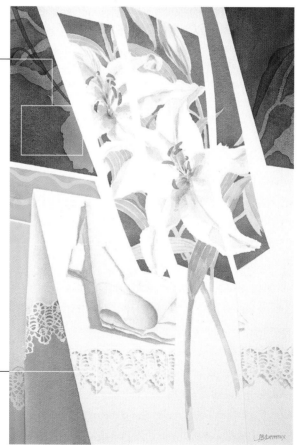

**Lillies – Fragments II**
**Jackie Devereux**

54 × 35 cm (21 × 14 in)
Watercolour on Arches
300 gsm (140 lb) rough paper

## Artist's Secret

Do not leave any masking medium on a painting for a prolonged length of time. Masking fluid may become difficult or even impossible to remove, and may turn yellow. Masking tape also can deposit its glue or even pull off the surface of the watercolour paper.

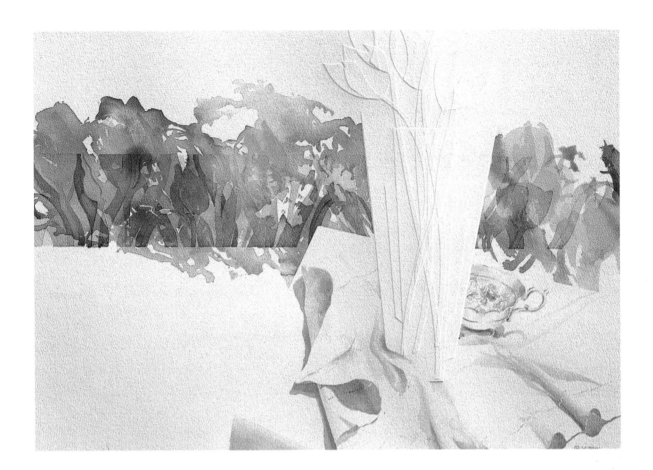

# Spring Border

This picture has both emotional content and great originality of approach. Jackie had enjoyed a vase of tulips, but eventually the flowers died and had to be thrown away. She decided to create an unusual image where the vase and the tulips it had held are seen as 'ghosts' against a colourful, very much alive garden border of tulips and foliage.

The central motif of ghost flowers and vase is a wonderful example of embossing. The combination of embossing, direct painting and large abstract 'negative' shapes of untouched white paper has resulted in a bold and innovative image. For the flower border, opaque pigments were applied first, and they were followed with transparent pigments, since opaque washes over transparent ones could destroy the translucent effect if the washes are not carefully controlled. The end result could only have been achieved with watercolour paints as the white of the paper shines through even the opaque pigments, flooding the image with sunshine and light. The painting needs little in the way of detailed explanation – it speaks volumes all by itself.

**Spring Border**
**Jackie Devereux**

53 × 73 cm (21 × 29 in)
Watercolour on Arches
300 gsm (140 lb) rough paper

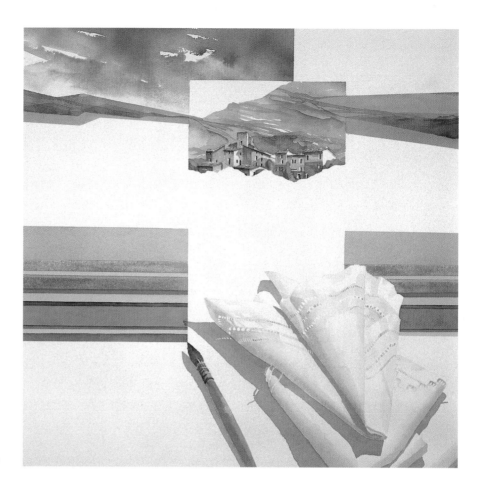

**Inside Out**

**Jackie Devereux**

50 × 70 cm (20 × 27 ½ in)
Watercolour on Arches
300 gsm (140 lb) rough paper

# Inside Out

Jackie loves to work outside directly from the subject, and this unusual 'landscape' image was inspired by a sketch made on the spot in the Garrigue area of France. However, she disliked the foreground area of the sketch, so she cut off that part. She propped up the remaining half-painted image on a table in her studio and was inspired to make it the focal point of a large painting.

The landscape of the Garrigue consists of sparse low-growing vegetation interspersed with bare earth. Jackie decided to emphasize this paucity of features by leaving large areas as white paper and by 'extending' the landscape visually in a semi-abstract and graphic way. The lower half of the painting, with its horizontal bands of colour and white napkin folded to give edges that echo the cut-off shape of the village scene, 'grew' entirely out of Jackie's imagination. Jackie is always prepared to allow a painting to develop organically in this way. An artist has to be prepared sometimes to trust instinct and risk failure in order to embrace creativity and reap unexpected rewards.

# Abandoned Heatwave

Sometimes the heat in the South of France is very fierce. When forced to work indoors one summer away from the scorching sun of a heatwave, Jackie decided to produce a 'minimalist' image that would suggest both the glaring heat as well as something of the mix of old and new in her environment.

Modern white garden chairs provided her with delightful shapes, as did the peeling walls of the ancient villa where she lives. Café tables are common in the region, always topped with sun umbrellas. The 'positive' whites in the painting – the chairs and the umbrellas – link with, and are echoed by, the 'negative' areas of untouched white paper. This juxtaposition creates an impression of sunlight glaring off whitewashed walls. Jackie has managed to say a lot, with just a few areas of paint and lots of white paper!

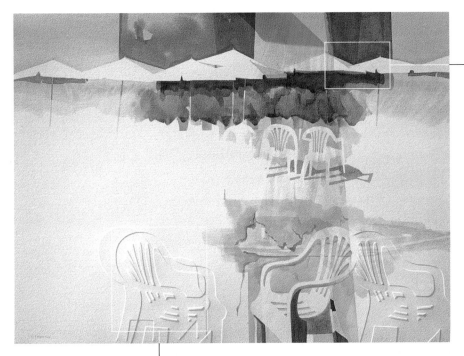

The white umbrella tops are 'revealed' areas of untouched white paper, and the rest of the image was painted around those shapes.

**Abandoned Heatwave**
**Jackie Devereux**
53 × 72 cm (21 × 28 in)
Watercolour on Arches
300 gsm (140 lb) rough paper

Jackie used embossing for two of the chairs; the others were painted.

# Inventive design

## Ray Evans

Since leaving art college in 1950, Ray Evans has had a long and distinguished career as a painter and illustrator, gaining a reputation nationally and internationally. He is a member of the Royal Institute of Painters in Watercolours and a member of the Royal Cambrian Academy. His paintings are in many public and private collections in Britain, Europe and the USA. In his early years as a painter Ray's passion was architecture and he was a Member of the Society of Architectural Illustrators. His superb draughtsmanship has stood him in good stead in the vibrant and innovative work he currently creates.

## From traditional to innovative

Ray's paintings of towns and buildings were, for many years, very representational in a traditional way. However, in 1996 a visit to the West of Ireland proved to be a turning point in his artistic career. His excitement with what he had seen in Ireland became the catalyst for an artistic 'sea change'. On his return from this trip he suddenly began to produce a series of paintings with a modern and lively look, moving away from pure representation to a more stylized approach and a strong feeling for shape and pattern.

Ray uses a restricted colour palette for each image, proving conclusively that it is possible to achieve powerfully effective images without employing riotous colour. His background and interest in design enables him to underpin exciting and joyous paintings with strong composition.

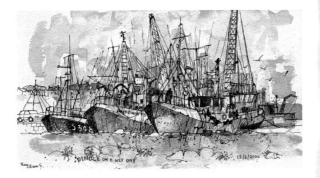

This example of Ray's early work shows evidence of fine draughtsmanship, but has none of the innovation that characterizes his recent works.

## Materials and palette

Ray draws on the spot and turns his sketches into paintings at home. He works on watercolour paper or acid-free mountboard. His technique is a response to his desire to create, within the rectangle, a strong arrangement of two-dimensional, semi-abstract shapes. In order to achieve form, depth and interest, and to avoid the monotony of flat areas of colour, Ray builds up his images with layers of colour, adjusting both tone and texture as he works.

Most of Ray's images have a colour theme. Vivid pure colour is often offset by passages of carefully mixed quieter tones and colours. He confesses to a great love for blue in all its varieties. He particularly likes to work on a dark ground in order to work from dark to light, so that the lights and near-whites become even more obvious and important. Since so many of Ray's paintings depend for their impact on strong composition and stylized shapes rather than on painting techniques, I have not isolated specific details of his work to study as for other artists' work in this book. Instead I have discussed each painting as a whole.

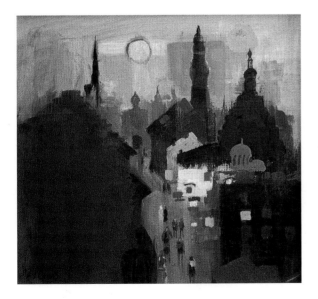

**Baltic City**

**Ray Evans**

28 × 31.5 cm (11 × 12 in)
Acrylic on board

This painting shows Ray's use of colour layering. For the left-hand area a dark shape was painted first, and several layers of red were painted over the top. This dense effect offsets the smaller shapes in the centre of the image.

# Techniques

Ray's images depend more for their impact on design and pattern than on technique. Sometimes, however, he gives a passage of colour extra depth with a layer of very fine tissue paper, applied with a mixture of Acrylic Fluid Gloss Medium and water – he calls the mixture 'varnish and water'. The collage work becomes a part of the picture, adding texture in a very subtle way.

Ray uses acrylic paints, and considers himself to be a modern watercolourist, since acrylic paints use water as their mixing medium. He uses his acrylics in exactly the same way as a painter would work with gouache, building up layers, but with one main advantage – acrylics, unlike gouache, do not lift when re-wetted. Acrylics are perfect for flat passages of colour and their flexibility allows Ray to adjust the layers for either transparency, opaque colour or texture.

**TISSUE TEXTURE**
Opaque colour was applied to coloured board, which is, essentially, acid-free board covered with Ingres paper. Additional texture was created by gluing thin white tissue paper to the surface with acrylic gloss varnish diluted with water.

**LAYERED COLLAGE**
Opaque colour was painted onto white board. Single and double layers of white tissue were glued over the top. The more layers of tissue, the more texture can be achieved.

### LAYERED PAINT

A transparent coat of dilute Burnt Sienna was painted onto cream board. Then dilute transparent blue was painted over the top and, finally, touches of opaque pale blue. The waterproof quality of acrylic paint means that there is no chance of the undercolour lifting and so altering the colour of subsequent layers.

### TONAL LAYERING

Here, layers of opaque pigment were layered over each other, creating an area of blue that has variety and more interest.

### DRY BRUSH

A warm grey patch of opaque paint was applied first, then blue opaque pigment layered over it using a 'dry-brush' technique to give a textured effect. Finally, dots and dashes of both dark and brilliant colour were painted on top with a small brush.

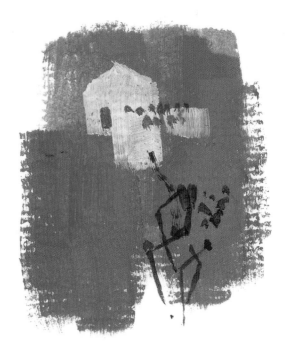

# Alpine Village

This painting is an imaginary scene, based on memories of a village in Italy. While composing the image Ray was 'thinking' in patterns. The block-like shapes of the houses are purely invented, but nevertheless there is a strong sense of place in the picture, as there is in all of Ray's paintings.

Notice how the lighter shapes within the rectangle are carefully linked and create larger passages of light forms. Echoing shapes underpin the composition, and the cool blues are enlived and contrasted throughout with complementary oranges and browns.

Some tissue layering can be found within the image, where it is used to create some texture and interest. Elsewhere, the flat areas of colour are thoughtfully considered and orchestrated so that every element of the picture remains firmly in place, correctly in space. The organization of the various elements is a *tour de force* of tonal juggling by the artist and could easily have gone wrong in less experienced hands.

**Alpine Village**
**Ray Evans**
26 × 30 cm (10 × 11 ½ in)
Acrylic on board

There is a strong cross shape within the rectangle – a vertical passage of light from centre top to centre bottom, and a horizontal arrangement of light shapes that link from the pale blue on the left, across to the central section, and on to the right.

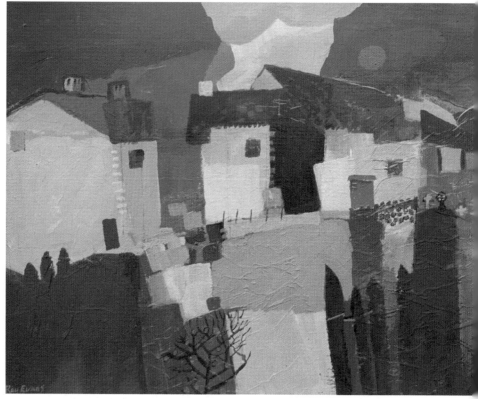

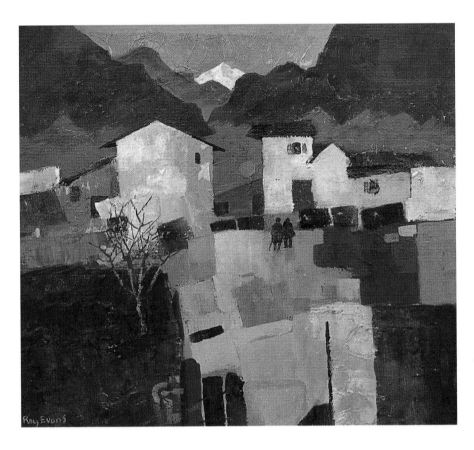

**Tuscan Village**
**Ray Evans**
27 × 30 cm (10 ½ × 12 in)
Acrylic on Ingres board

## Tuscan Village

Like *Alpine Village* this painting also has strong, dynamic echoing shapes and a cross-shaped composition. Touches of red pull the eye horizontally across, helping to draw attention to the two little central figures. Figures always attract attention, but Ray has 'knitted' them tonally into their surroundings and, instead, the light shapes of the houses are visually more important in this image.

Notice how Ray has 'activated' the simple shapes of the houses, by building up layer upon layer of subtle colour within them. The biggest house, on the left, is made more interesting by the use of cool blues, whites and greys, set alongside the warmth of the small red house to its left. Note, too, the 'counterchange' of the spidery linear marks for the tree branches painted dark against the light of the house, while the tree's trunk is painted light against the dark behind it.

Ray has used a great variety of subtle colours, including soft creams and pinks, and tiny touches of yellow and green. These small complementary-colour 'accents' add touches of richness and variety, and subtly attract attention.

## Artist's Secret

Soft handkerchief tissues are often made in layers. For very subtle texture, gently prise the layers apart, and use a single, gossamer-fine layer for texture. It is likely to crease as you position it down, but this is fine as it simply adds to the interesting texture.

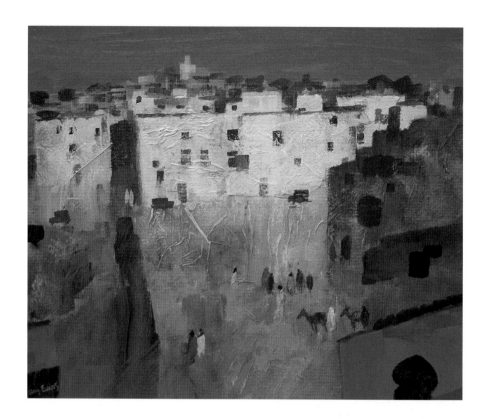

**Chechaouen, Morocco**

**Ray Evans**

20 × 25 cm (8 × 10 in)
Acrylic on board

## Chechaouen, Morocco

Ray has painted this old picturesque mountain town in Morocco from a distance, perched high up on the hillside. Layering and tonal adjustments are very much at work in this picture. Tissue collage provides just the right feeling of old, peeling whitewash and, below the houses, it creates a lovely texture for the terrain of the hillside. A brilliant sun is shining; the white houses are sandwiched between the rich dark blue of the sky and the shadow shapes on the right-hand side of the painting and the darker tones of the lower half of the hillside. As a result, the whites, and the paler tones of the sunlit ground below the houses, really glow.

**Chechaouen 2, Morocco**

**Ray Evans**

41 × 30 cm (16 × 12 in)
Acrylic on board

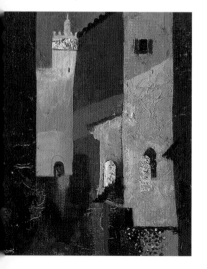

In the painting of the narrow street (left) Ray has captured the claustrophobic feeling of the soaring walls with tall rectangles of colour. They are made all the more interesting with layers of tissue, which create texture in the pigment.

Shafts of sunlight streak down into the winding streets, illuminating corners here and there. Ray has used some touches of gold leaf, which add forcefully to the composition, giving light, drama and excitement.

# Tunisia

Ray's painting shows a small corner of an ancient village in Tunisia, where towering, thick, sometimes curved, whitewashed walls and tiny windows keep out the heat and, possibly, prying eyes. This image is a revelation in how just a few simple shapes can tell a whole story. The little windows, 'lit' with touches of gold leaf, and the few scattered cobbles on the ground are enough to tell us all we need to know about this private world. We feel the coolness of the shadow, we understand the packed nature of the buildings, we sense the silence of the street, and we are offered just a hint of the life and activity behind those tiny windows. The curved nature of the tall shapes on the left is sufficient to break up any monotony in the echoing vertical forms. There is variety, too, in the application of paint. The tones are subtly built up and broken up, and the tissue collage provides texture and interest.

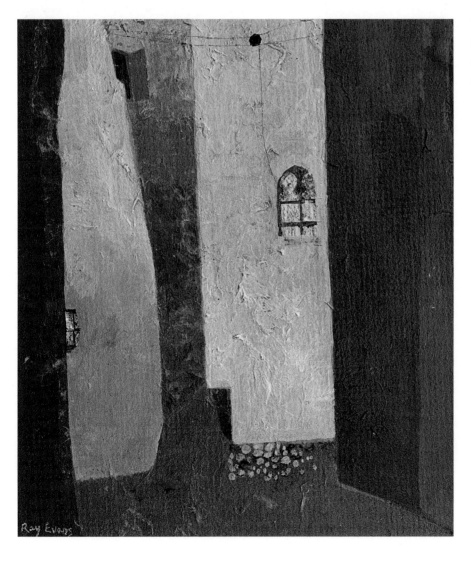

**Tunisia**
**Ray Evans**
26 × 21 cm (10 × 8 in)
Acrylic on board

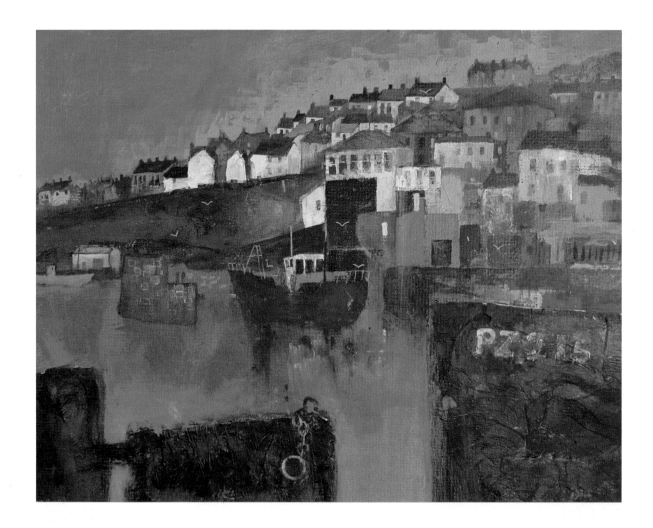

**Newlyn**

**Ray Evans**

30 × 36.5 cm (12 × 14 in)
Acrylic on board

# Newlyn

Ray was attracted by a particular red, rusting boat in the harbour at Newlyn, Cornwall, as well as the corroding surfaces of other boats nearby. A predominantly blue image is enlivened by the central shape of the red boat, and tiny shapes of the same colour are found elsewhere in the picture. Layers of tissue paper were collaged onto the hull shapes in the foreground, and these strong shapes were painted with layers of blue until the desired richness and depth of colour was achieved. Between these large, important foreground shapes there is a 'pathway' of lighter blue that leads the viewer's eye into the buildings that make up the background of the composition.

Despite the fact that there are recognizable elements in the picture – boats, houses, water, sky – there is nevertheless a strong feeling of abstraction because of the echoing shapes. The 'negative shape' of the water is echoed in the upper part of the image, within the rectangular shapes of the houses on the hillside.

# Slate Country, North Wales

This painting is a classic example of Ray's innovative technical approach and his powerful compositional skill. The image consists of village houses in the middle distance – a frieze of echoing block-like shapes – held firmly in place by the dark shapes of the hills beyond. Layers of gentle colours and tissue collage give a sense of a cloudy sky behind those dark, looming hills. The foreground is also collaged with tissue and overpainted with a variety of small and large abstract shapes that suggest landscape texture and form.

Small ovals of brilliant Coeruleum on the hills are echoed elsewhere by circles of dark red, while subtle green, iron-grey and blue shapes in the foreground are overpainted with, and offset by, passages of milky ochre. Crisp white tissue 'lines' help to draw the eye up through the foreground to the houses beyond.

**Slate Country, North Wales**

**Ray Evans**

33 × 35 cm (13 × 14 in)
Acrylic on Ingres board

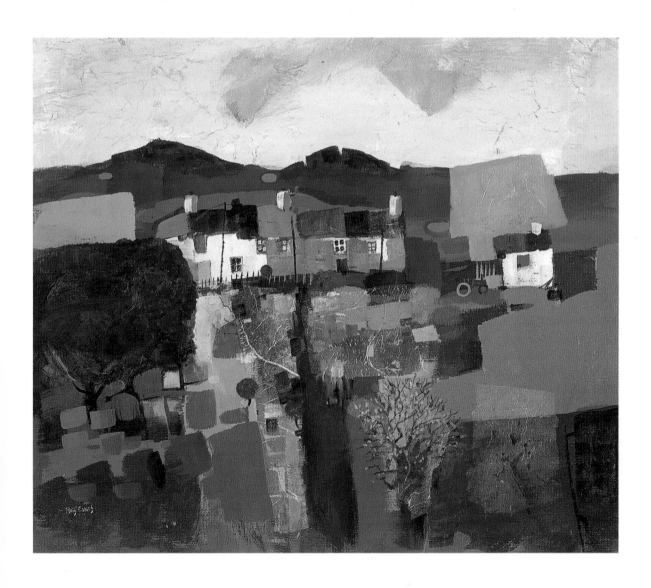

# Happy Valley, North Wales

Ray was immediately attracted by this jumble of farm buildings built under the shelter of a Welsh mountain. There is a general rule of composition – that of never having a fence, wall or gate directly in the foreground, since it prevents the eye from moving back into the middle distance – but Ray's painting shows how to break this convention.

In Ray's picture small light shapes illuminate the scene; touches of red, pink and orange on the buildings link with passages of cream, pink and ochre in the fields. The light vertical post of the sign in the foreground links with the light pink shapes 'behind' it. This takes the eye up to the pink front of the building beyond, with its brilliant red doorway. So, even though there is a brick wall as well as a closed gate in the foreground, the viewer moves into the mid-distance.

We also visually step beyond the gate, which acts as a kind of visual 'ladder', to follow the blue of the path into the distance.

**Happy Valley, North Wales**

**Ray Evans**

21 × 26 cm (8 × 10 in)
Acrylic on board

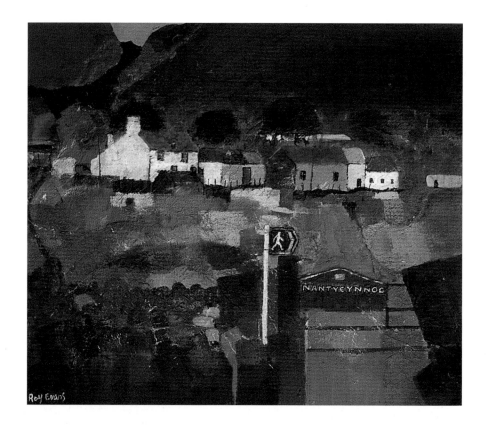

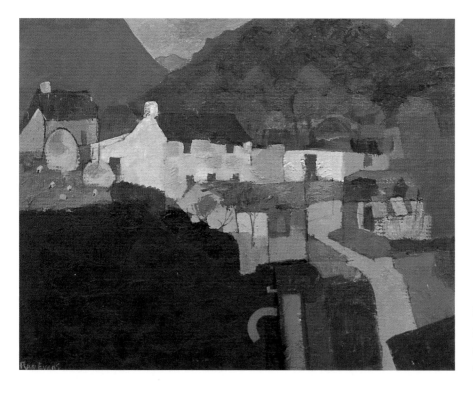

**Farm, North Wales**
Ray Evans
22 × 27 cm (9 × 11 in)
Acrylic on Ingres board

## Farm, North Wales

The light tones of the buildings link with simplified shapes that tumble down, almost like a waterfall, to the bottom right of the painting. However, a dark shape in that corner prevents the eye from drifting out of the picture and 'bounces' us back. Stylized shapes in subtle tones of ochre, red and green suggest a wooded area, and the hill looming behind has suggestions of texture, bringing it slightly closer than the farther blue hills. The dark, dramatic foreground shape at lower left is textured with tissue collage and overpainted.

**Welsh Village**
Ray Evans
22 × 27 cm (9 × 11 in)
Acrylic on board

## Welsh Village

Ray has used shape and texture boldly here. Stylized curving forms take the viewer to the cluster of houses in the middle distance. Texture is partly achieved with overpainted tissue collage, but also supplied by the painted foreground shapes. Small dots and dashes suggest a tree; block-like forms in layers of closely toned soft colours suggest a wall or path. The dominant blue shape to the centre right could be a village pond reflecting the sky and echoes other curving elements within the picture.

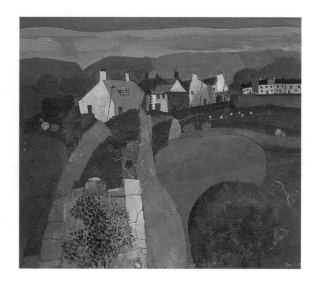

# St Adalbert's Church, Krakow

In this painting Ray allowed the tiny ancient church to dominate, placing the subject in the centre. Nevertheless, it is not isolated – the dark blue shapes on and around the building visually link with other shapes within the rectangle. Both the left-hand side of the dark area and the right-hand side of the church are cleverly linked to the edges of the image by small light shapes, possibly umbrellas in the square, which act almost like tiny 'hinges', holding the central shapes firmly in place.

The tree is stylized in shape, echoed by its shadow and also by the windows and roof of the church. Similar small circles can be found elsewhere in the composition, carefully painted dark against light, or light against dark. The circles provide a note of contrast and variety in a composition dominated by rectangles and squares.

The façade of the church is a build-up of many layers of closely toned colours, as is the sky, dramatically enlivening the surface.

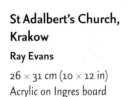

Initial sketch for St Adalbert's Church, Krakow

**St Adalbert's Church, Krakow**

**Ray Evans**

26 × 31 cm (10 × 12 in)
Acrylic on Ingres board

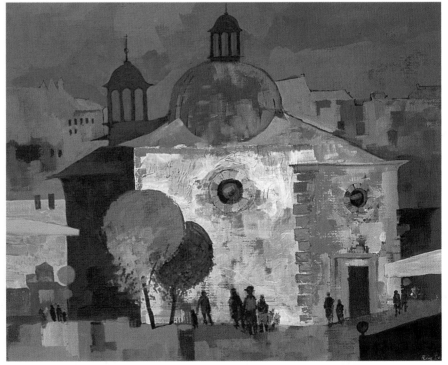

## PROJECT • Designing with flat shapes

Choose a watercolour painting you have done, or a drawing from your sketchbook. Ideally, select an image that you have painted in a traditional way with three-dimensional form. The idea of this exercise is to redesign your painting, so that you create an image composed of flat coloured shapes. You could also stylize the shapes to give a more modern, semi-abstract effect.

### Rearranging and changing

Repaint the image in either gouache or acrylics, using flat areas of colour. You can choose to adjust colour dramatically to alter the atmosphere completely, you can isolate shapes from each other with the use of outline, or you can rearrange shapes and stylize them if you wish. The important point is to let go of the idea of three-dimensional form as revealed by the light, and to concentrate on flat shapes. It may seem strange, and perhaps even uncomfortable to you, to work in this way … but it may also feel very liberating!

Try varying the textures within the shapes with overlays of dry-brush work, tiny linear accents, and by overpainting with a slightly lighter tone, or even colour, leaving some of the darker underlayer showing.

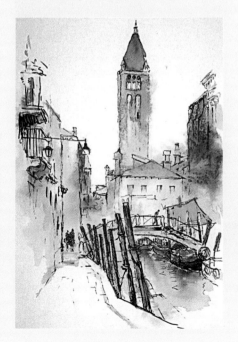

A typical backwater canal in Venice – architectural subjects are always good for this kind of flat-shape treatment. The original watercolour sketch (left), done on the spot, is also fairly 'flat', but the look of the gouache version is quite different.

**Rio St Barnaba**
**Jackie Simmonds**

28 × 20 cm (11 × 8 in)
Gouache on 140 gsm (90 lb)
Bockingford paper

# Creative colour

## J. Richard Plincke

J. Richard Plincke originally trained as an architect, but now works full time as a professional artist. He was elected to membership of the Royal Institute of Painters in Watercolours in 1984, the National Watercolor Society, USA, in 2000, and the Federation of Canadian Artists in 2002. He has won numerous art competitions, shown his work in many galleries and exhibitions, and his paintings are included in various public and private collections in Britain and abroad. He has also carried out designs for works in tapestry and stained glass, and has appeared in two BBC television programmes.

## Colour and rhythm

Richard considers himself to be very much 'an experimental watercolourist', and his working methods are varied and fascinating, involving watercolour, acrylics, and mixed media effects. This is an artist who rather likes to throw away the rule book when working on a painting.

Many of his brilliantly coloured works start in a spontaneous, experimental way, beginning with colour and rhythm on a wet surface, and then the painting is developed in response to his highly creative imagination, balancing this instinctive approach with well-controlled design. At other times a particular idea is the starting point for a painting, and that painting will develop along the lines of a definite theme. Even then, Richard's nature ensures that his vigorous

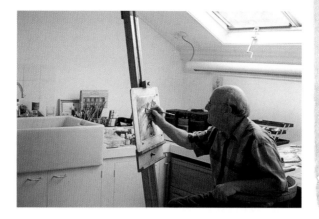

Richard at work in his studio,
where he uses a variety of media.

**Richard's palette
includes:**

Naples Yellow

Cadmium Yellow

Aureolin

Raw Sienna

Burnt Umber

Cadmium Orange

Cadmium Red

Alizarin Crimson

Emerald Green

Olive Green

Viridian

Cobalt Green

Manganese Blue

Cobalt Blue

French Ultramarine

Mauve

Ivory Black

Lamp Black

Fluorescent Orange
(gouache)

Fluorescent Red (gouache)

experimental painting approach is never stifled, and that the paintings are never sterile or overworked. Richard's paintings range from totally abstract, to semi-representational – yet whatever form they take, every painting is charged with the expressiveness and excitement of discovery.

## Materials and palette

Richard works on stretched watercolour Not paper, either 190gsm (90 lb) or 300 gsm (140 lb), and generally uses synthetic brushes, preferring them to sables, because of the vigour with which he works. His absolute favourite is his 5 cm (2 in) flat brush, also a synthetic mix, which is used for all the early washes in his works, and occasionally later on, for what Richard calls 'an instinctive sideways swipe that can simplify an entire area of the image'.

Richard also uses a variety of collage materials in many of his works and employs other found 'tools', such as the edge of an old credit card for the occasional sharp line, or a knife for scraping out. In the hands of an inventive artist almost any household or craft implement can be put to good use.

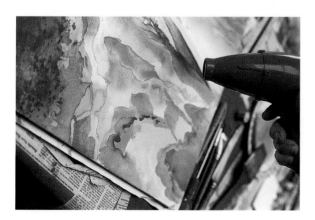

A hairdryer can be an indispensable tool for speeding up the drying time of washes.

# Techniques

Richard will try anything and everything, and the skills he learns from experimentation are put to good use in practice. Together with traditional watercolour paint, poster paint, and acrylics, Richard uses collage with a variety of materials, salt grains, wax resist, scratching and scraping, masking, and even spray enamel for unusual textural effects. A favourite colour is Manganese Blue, but, as Richard points out, the original pigment, which would granulate beautifully and add to the texture in a painting, is no longer available. He has managed to track down a large stock of this marvellous colour, however, and hopes that he has enough to continue with for many years to come.

**WAX RESIST**
Interesting textural effects can be achieved with wax resist. Try either rubbing the paper with beeswax, or drawing with oil pastel, before applying watercolour.

**IRIDESCENT ACRYLIC INK**
The blue circles were made with iridescent acrylic ink, which is slightly pearlized, and opaque in effect. The grey textured area is acrylic paint, dragged across the paper in a dry-brush fashion.

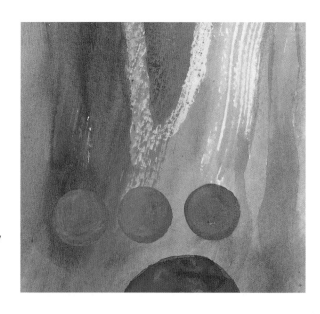

## SALT SPATTERING

Textural effects can be achieved in a variety of ways – by spattering paint, spattering water into a damp wash, or sprinkling salt onto a damp wash and allowing it to dry. It is worth experimenting with all of these effects, as the results can be random.

## SPRAY ENAMEL

An original multi-coloured watercolour wash was sprayed with both silver and black spray enamel while the previous washes were still very wet. Then the board was tipped to encourage the paint to run and spread in order to develop interesting and useful textures.

## GRANULATION

Manganese Blue 'granulates' when painted very fluidly. This is true of other colours, too, and experimentation will prove which colours will behave in this way.

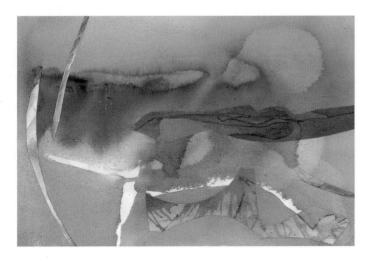

## 'CAULIFLOWERS'

Collaged strips were cut from failed paintings, and applied to an original base of watercolour, using PVA glue. Here, clear water was also dropped into areas in the original wet wash, creating 'cauliflower' shapes.

## Sketches

Sketches often provide an insight into an artist's thought processes. These lively drawings taken from Richard's sketchbooks show that, although obviously working from figurative sources, Richard begins to stylize and exaggerate forms and shapes from the outset, and starts to find patterns and rhythms in his source material. It is certainly possible to see how any one of these sketches could be the inspiration for an exciting abstract painting.

# Forest Ritual

This image grew out of an intuitive, experimental beginning, and is more to do with the feeling of a strange event in a forest rather than the look of a real forest. After applying wet-into-wet washes in a free and random manner, which Richard calls 'crashing around with very wet washes', he began to apply collage pieces with PVA glue, building up the image slowly using a variety of materials. These included a tissue wrapping paper from a biscuit, gift wrapping paper, pieces of cork, sections torn from discarded paintings and two buttons! But there is nothing random about the later stages and the placement of the collaged items. As the concept unfolded he made adjustments, taking account of movements, directions, weight of tones and exciting shapes.

**Forest Ritual**
**Richard Plincke**

41 × 46 cm (16 × 18 in)
Watercolour and collage on
Saunders Waterford 190 gsm
(90 lb) paper

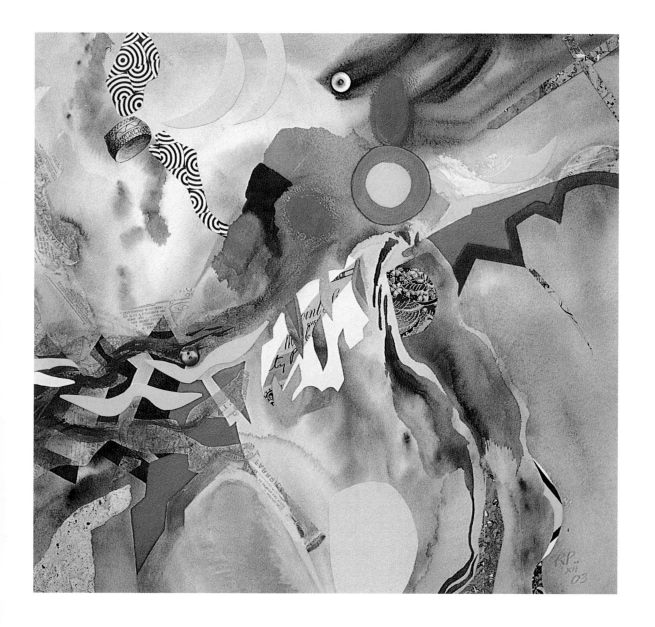

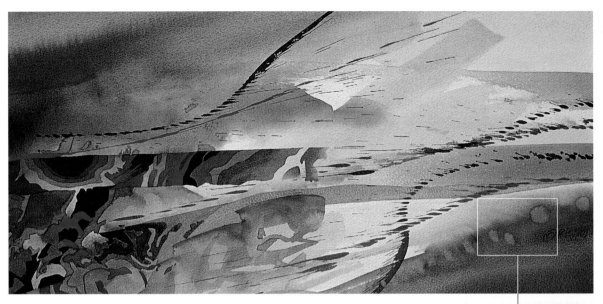

**Excalibur**

**Richard Plincke**

37 × 74 cm (14 ½ × 29 in)
Watercolour on Saunders
Waterford 300 gsm (140 lb)
paper

Water dropped onto a wet
blue wash, which was laid over
a pink wash, dissolved some
of the blue pigment and
revealed the pink beneath.

## Excalibur

This powerful image began its life in a much simpler form, which Richard
found unsatisfying. Some ten years passed before he finally resolved the
painting in this way. Richard 'lived with it' and began to realize that the central
section looked rather like a sword, and so 'Excalibur' was born.

The drama of the piece was emphasized by a technique that Richard calls
'flung paint'. This involves the 'dangerous', experimental procedure of flicking
a well-loaded brush at the image. If this should fail the picture can easily be
ruined – hence the use of the word 'dangerous'. Richard regards the process as
a minor miracle when it actually works. To try it four or five times, as he did in
this painting, is, he claims, more than a little foolish!

It is worth noticing that the 'flung paint' technique creates very distinct
directional forces within the image that link with the edges of the rectangle in
a positive manner.  These directional forces could, if produced in a haphazard
way without prior consideration, wreck the composition of the painting by
creating visual pathways that add nothing to, or possibly even destroy, other
movements within the rectangle.

# Conflicting Interests

Richard's images are all about 'picture building'. He does not reproduce exactly what he sees – the painting itself takes precedence over the subject matter. So the subject matter is, for Richard, a point of departure and what follows becomes an adrenalin-fired balancing act as the image gradually evolves, one painting decision leading to another, until a conclusion is finally reached.

An outside terrace, but an internal view through glazed double doors, was the starting point for this image. There are some recognizable elements – a hammock, a lounge chair, a birdfeeder and a golf ball – but these objects simply become part of the abstract 'whole', an expressive interpretation through pattern.

**Conflicting Interests**

**Richard Plincke**

74 × 56 cm (29 × 22 in)
Watercolour on Saunders
Waterford 190 gsm (90 lb)
paper

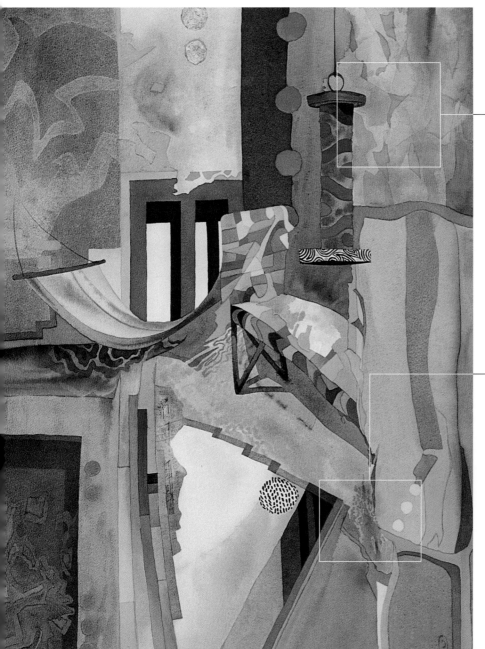

This section was carefully masked, and then paint was sprayed on with a mouth diffuser. Additional shapes were painted on with transparent watercolour.

It is not always easy to achieve powerful opaque colour with regular watercolour pigments. These yellow circles and orange lines were painted with fluorescent colour, which glows brightly, particularly when painted against darker tones, adding a dramatic punch to the image.

Compositional pencil sketch

# Conference

On a trip to the USA Richard sketched some traditional, dark-wood dolls sitting on a shelf. The subsequent painting has an interesting composition; the simple background above the figures and the light shape below balance a central kaleidoscope of strong, vibrant small shapes. There is a lovely contrast between varied, transparent watercolour washes, and crisp, colourful, opaque hard-edged shapes. The figure on the right of the sketch has been cropped out. Richard enjoys the tension created by cropping in this way, having learned much from the paintings of Edgar Degas (1834–1917), who frequently used this device. There is a vast amount of energy in this image because of the variety of the shapes and the brilliance of the colours. The faces are left purposely blank, but there is great expressiveness in the stance of the central 'figure'.

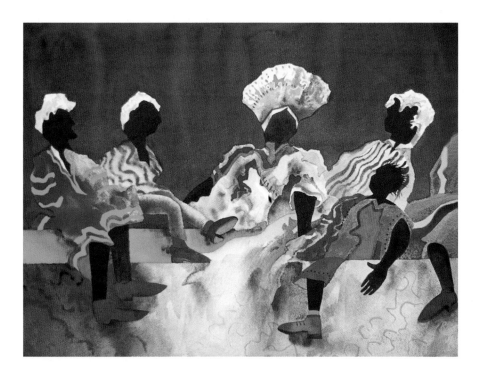

**Conference**
**Richard Plincke**

38 × 50 cm (15 × 19 ½ in)
Watercolour on Saunders
Waterford 190 gsm
(90 lb) paper

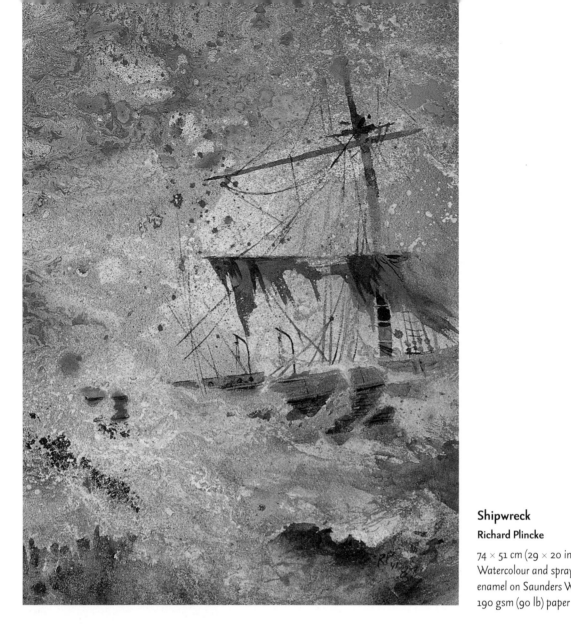

**Shipwreck**
**Richard Plincke**

74 × 51 cm (29 × 20 in)
Watercolour and sprayed
enamel on Saunders Waterford
190 gsm (90 lb) paper

# Shipwreck

For Richard, this is an unusually restrained picture in terms of colour, but
certainly not in terms of atmosphere or paint application. We can see that the
rigging and sails of an ancient ship have been torn to shreds by the fury of a
storm, but the rest of the painting is just a mass of swirling marks. Richard has
created a simple, but powerful image with a minimum of 'information', allowing
the viewer to use his or her imagination to interpret the story. Spray enamel
was used here, over initial wet-into-wet washes. Black, blue, red, silver, orange
and yellow enamels were used in turn, sometimes onto wet paper, sometimes
onto the dry surface. Although the technique is completely experimental,
nevertheless, as with any technique, experience has taught the artist how to
control the medium, making it do what he wants it to do.

To paint the top of the hill water was dropped into a damp area of thick pigment. Then the board was tilted, dispersing the water and pigment further.

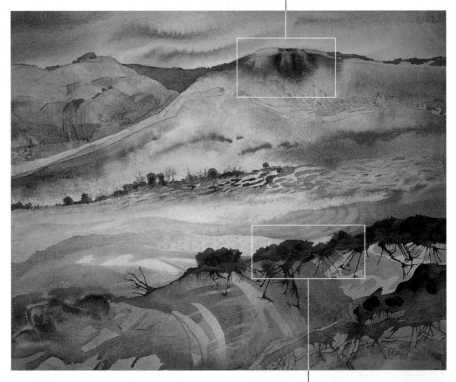

**Estuary**

**Richard Plincke**

36 × 43 cm (14 × 17 in)
Watercolour and ink on
Saunders Waterford 190 gsm
(90 lb) paper

For these trees Richard painted a line of dark shapes on top of dry washes. Then, while the paint was still wet, the pigment was pulled out and down, by blowing at it fiercely, together with the use of the 'wrong' end of the paintbrush, to create these sharp linear effects.

# Estuary

Richard spent his childhood in Devon, where he would pass much of his time sketching. This painting is a scene of one particular estuary, but it is based on one of his sketches, and it evokes memories of the many estuaries to be found throughout this beautiful county. Richard has used an exciting colour palette, with plenty of imaginative variety, and a dynamic composition made up of strongly curving forms and dramatic shapes that suggest landscape elements rather than describe them very literally. Richard's favourite colour, Manganese Blue, can be seen granulating nicely in the central section.

# Heavy Weather

Richard often sails in his spare time, and this image was created after a dramatic personal experience on board a sailing boat in very heavy weather. He tried to make a sketch at the time, which was, not surprisingly, soaked in spray. So, later, he took a photograph when the boat was on the same tack and used the information from the photograph, together with his vivid memories of the event, to paint the finished watercolour.

This approach evokes memories of J. M. W. Turner (1775–1850), who had himself lashed to a ship's mast for four hours in a fierce storm in order to experience the power and fury of the wind and the sea. Despite his misgivings, Turner survived this terrifying ordeal, committed the experience to memory, and later produced one of his most awe-inspiring works: Snow Storm – Steam-boat Off Harbour's Mouth Making Signals in Shallow Water, and Going by the Lead (1842).

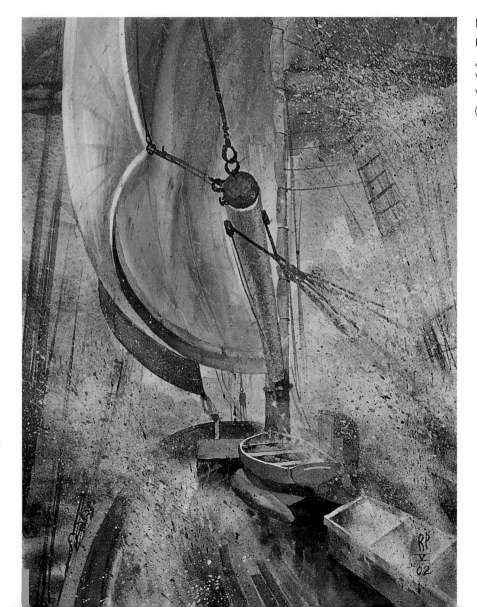

**Heavy Weather**
**Richard Plincke**

42 × 33 cm (16 ½ × 13 in)
Watercolour on Saunders
Waterford 190 gsm
(90 lb) paper

# Dynamic detail

## Catherine Brennand

Catherine graduated from University College Chichester with a degree in Art and Design, and her first job, as a Technical and Graphic Artist in the construction industry, awakened her interest in architecture. Over the years she has developed a highly individual interpretation of buildings and building façades and has won a number of important prizes for her work. In 1992 she won the Best Painting of an Architectural Subject at the RI exhibition and was invited to become a full member of the RI. In 2000 Catherine won the Llewellyn Alexander Gallery Award for 'The finest watercolour in the exhibition'.

## A love for architectural detail

Many of Catherine's ideas come from her travels to interesting towns and cities. She particularly likes challenging architectural detail, and often paints parts of buildings, such as a shuttered window or two, an unusual balcony, or a fascinating doorway. The texture of different materials and surfaces is an important element in her work, and she uses watercolours, together with resists and collage, in order to achieve the effects she desires.

Catherine's compositions are unexpected and exciting. The viewer finds his or her eye travelling strongly up the surface of a building, or seeing a façade from an unusual, dynamic angle, as the artist employs obvious perspective distortion in order to add energy and impact. Colour is carefully considered and used

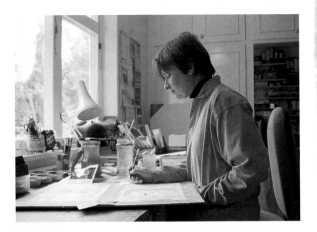

*Catherine at work in her light-filled studio at home.*

fearlessly, and light, too, is used creatively, adding to the atmosphere of each piece and emphasizing a sense of place. In each of Catherine's paintings there is a tension between freely applied marks and her subsequent careful painting and attention to detail. It is this tension, frequently coupled with soaring, dramatic perspectives, which gives these images a unique power.

## Materials and palette

Catherine uses pure watercolours, and likes to keep to a fairly limited palette, preferring to mix her own colours from a basic set of four, with the use of Naples Yellow for the occasional, slightly more opaque passage. She uses artist's quality pigments, which sometimes differ from student's quality. For instance, artist's quality Prussian Blue, a colour that Catherine uses often, varies dramatically in student's quality. Catherine believes that it is worth paying the extra cost involved to have the best quality materials. She works on stretched watercolour paper and enjoys using Winsor & Newton Cotman 400 gsm (200 lb) paper, which she finds absorbent and able to take lots of 'punishment'.

*Catherine often prefers the strength and durability of man-made fibre brushes because she frequently 'scrubs' the paint onto the surface. Her well-used brushes range in size from a 13 mm (½ in) one-stroke down to a No. 000 for minute detail.*

# Techniques

Catherine is, essentially, a traditional watercolourist in that her paintings are built up carefully in transparent layers of colour with total understanding of pigment qualities. Without paying attention to pigment qualities – the density and opacity of each colour – a painting can easily be spoiled, and transparency can be lost. She leaves the white of the paper for highlights, and allows the brightness of the white paper to illuminate the washes. Despite the fact that she may use as many as 15 layers of colour, every area of colour glows with life.

Catherine mixes traditional methods with a modern, experimental approach, combining watercolour washes with collage materials, and using resists to create interesting areas of texture and depth.

**LAYERED COLOUR**
Using Cadmium Red, five layers of colour, beginning with the largest square visible here, were built up to achieve a rich, strong red that was still beautifully transparent.

**ROLLERING**
In the early stage of a painting, Catherine may use a rubber roller to create areas of texture. Two or three passes with the roller gave an interesting layered effect here.

**SPATTERING**
Catherine cites a sore wrist as the result of a great deal of flicking and spattering of paint to achieve this lovely textural effect!

## PVA RESIST

PVA glue acts as a resist to watercolour. This example shows the effect of several layers of PVA and watercolour, the darker watercolour washes adding some depth in colour and dimension.

## WAX RESIST

Applied to white paper, the white line of a sharpened wax candle remains throughout the working, but applied to a layer of colour that colour will remain. Here, candle wax was applied to some of several layers of green.

## TISSUE TEXTURE

Tissue paper was glued to watercolour paper with PVA, applied undiluted with a small flat spatula. Slightly crumpling the tissue paper provided raised linear areas where the paint collects, as well as at the edges of the tissue.

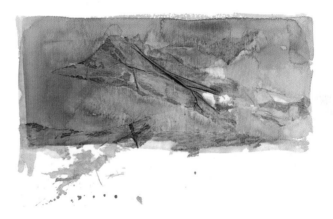

## COLLAGE WITH WATERCOLOUR

Catherine often uses found materials to collage onto her paintings, making them very much part of the textural effect. Here, she used paper bank notes, postage stamps, and wine and water labels together with acid-free tissue and touches of gold leaf.

# Tiffany, London

This image makes use of strong divisions of the rectangle. The white of the paper plays an important role in this powerful design. The composition forms a T-shape – the white 'Tiffany' shop title and the blue horizontal lines above it form the crossbar of the T, while the central window below, with its light reflections, provides the vertical of the T shape.

Catherine cleverly links the lower half of the picture with the top section by using the blue flag, ensuring it breaks across the horizontal area of white. This takes the viewer down to the windows below, with their contrasting geometric elements – strong verticals, echoing horizontals, and beautiful arcs that lead the eye from left to right. Squares, rectangles and curves are repeated throughout, providing visual harmony, while variations in scale prevent monotony. Areas of counterchange – dark against light, and light against dark – provide visual drama. The whole image has been painted with a mixture of blue and brown.

No masking was used for this lettering. It was just a matter of painting carefully, using blue to reveal the yellow.

**Tiffany, London**

**Catherine Brennand**

37 × 34 cm (14 ½ × 13 ½ in)
Watercolour on 400 gsm
(200 lb) Not paper

Notice how the reflection of the building opposite adds depth to the painting. Catherine enjoys confusing the eye with shapes that may be deep within the shop, in the window, or part of the reflection.

**Longchamp, London**
**Catherine Brennand**
37 × 34 cm (14 ½ × 13 ½ in)
Watercolour on 400 gsm
(200 lb) Not paper

# Longchamp, London

The colour in this London shopfront image depends upon restrained complementaries. In this case it is a pairing of red and green, with the red family being the dominant primary colours, and muted greens the subsidiary secondary colours.

Powerful design qualities dominate this image. Turn the picture upside down for a moment, or squint through half-closed eyes, and this will immediately become apparent to you. The large rectangles created by the vertical door and window supports are echoed again and again, making shapes within shapes. The edges of the rectangle hold in and reinforce these shapes by echoing the vertical and horizontal linear elements. The strong diagonal of the fascia board, which slices across the top of the image, prevents any monotony, while the cool, white areas break up the image and link with the edges of the rectangle, helping the viewer to 'read across' the scene.

**Ayuntamiento, Seville**

**Catherine Brennand**

37 × 55 cm (14 ½ × 21 ½ in)
Watercolour and collage on
400 gsm (200 lb) Not paper

## Ayuntamiento, Seville

Seville is a city steeped in history. The Ayuntamiento (Town Hall) was built in
the sixteenth century in Renaissance style on the remains of the former
San Francisco monastery. Catherine's painting represents a tiny segment of
the Ayuntamiento's amazing façade.

The colour was kept deliberately simple and harmonious in this painting
because it is the fascinating architectural detail that is of primary importance
in this piece. To balance the strong areas of detailed drawing and information,
Catherine has used freely applied watercolour washes, and spatterings of
colour. Despite the restrained palette there is, nevertheless, plenty of drama
in the image because of the tonal contrasts and soaring perspectives.

**Feathers Hotel, Ledbury**

**Catherine Brennand**

36 x 53 cm (14 x 21 in)
Watercolour and collage on
400 gsm (200 lb) Not paper

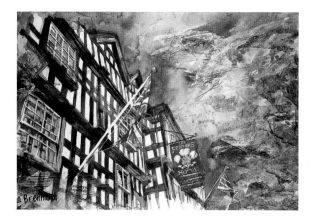

## Feathers Hotel, Ledbury

As well as the unusual perspective, the simplicity
of the colour plays a strong part in the emotional
impact of this painting. The composition of the
piece is unusual, too, with a fifty-fifty division of the
rectangle – half sky and half building. Strong
diagonals slice across in varying directions and the
activity of the surface areas, especially the collaged
sky, ensures that the image is anything but static!

# Culzean Castle, Scotland

This romantic castle (pronounced 'Cullain'), originally a fortified tower, was converted in the late eighteenth century by Robert Adam for David Kennedy, Earl of Cassilis. When the Kennedy family donated the castle to the National Trust in 1945 they asked that the top floor be given to General Eisenhower as a thank you from the people of Scotland at the end of the Second World War. Eisenhower first came to Culzean in 1946 and visited the castle three more times, once as President.

Catherine has used a more gentle perspective for Culzean Castle, and straightforward complementary colours of blue and orange, but her approach is innovative. The castle sits between two areas of blue – a strong sky shape, painted with freedom and vigour, and the blue shadows at the base of the image. The careful drawing of the details of the castle, combined with lively, loose painterly passages, shift the image from a traditional piece to one that is far more modern, creating atmosphere and an abstract feel.

The clouds in the sky contain, extraordinarily, pieces of local newspaper, collaged on with PVA glue, and then overpainted with washes of watercolour. The PVA glue was also used as a glazing medium over the top of the painting and the collage.

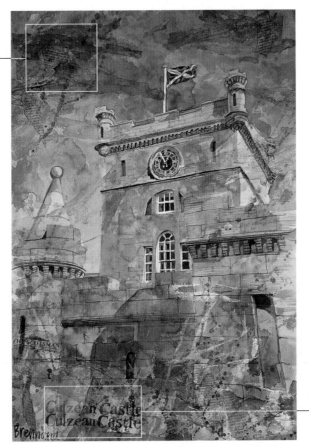

**Culzean Castle, Scotland**
**Catherine Brennand**

55 × 37 cm (21 ½ × 14 ½ in)
Watercolour and collage on
400 gsm (200 lb) Not paper

Catherine sometimes uses calligraphy as a painting tool. Here, the name of the castle was carefully painted in both blues and oranges to become part of the image.

# Synagogue Doorway, Jerusalem

This dramatic image is a perfect example of Catherine's use of transparent washes, combined with collage woven into the painting's surface to give the impression of texture from a distance. The building is of Jerusalem stone, which has a rough-cut surface and is very warm in colour. When struck with sunlight, it shimmers and glows, and at sunset it is suffused with deep pinks and honey-golds.

Pieces of local newspapers, wine labels, postage stamps and certificates were pasted down with PVA glue and painted over with watercolour washes to enhance the impression of the old stone walls of the ancient synagogue. Intense hot reds and oranges were used, together with gold leaf, all of which emphasize the feeling of the heat in this part of the world. And, given that red is, in Western society, often associated with danger, the colour also acts as an expressive vehicle for the artist to suggest something of the unsettled nature of the volatile city that is home to this doorway.

The image of the flag was, in fact, a collaged newspaper cutting, but it has been overpainted with dark blue watercolour to achieve a more painterly effect, and subsequent additions of tissue collage, watercolour washes and gold leaf 'knit' the collaged area into the picture.

**Synagogue Doorway, Jerusalem**

**Catherine Brennand**

74 × 58 cm (29 × 23 in)
Watercolour and collage on 400 gsm (200 lb) Not paper

Newspaper cuttings, tissue overlays, postage stamps and wine labels were overpainted with washes and splashes of watercolour.

# Painting in progress

Paris has always attracted painters and Catherine is no exception. However, she has a unique approach to painting in this lovely city. The Place Vendôme is one of the most beautiful squares in Paris, and it is home to the Ritz Hotel, the house of Frédéric Chopin (1810–49) and some exclusive shops, such as Cristofle. Over the years Catherine has painted almost every building in the square! Shop façades of this kind provide her with architectural detail, colour and interest in the contents of the windows and the reflections to be found in the glass.

**Step 1**
Catherine always starts with a careful pencil drawing onto stretched watercolour paper. Although this may later be covered with numerous washes, she still prefers to start with a good deal of information on the paper. Here the drawing has its first layers of watercolour; some were freely applied with spattering and undefined shapes, while in other areas the washes relate to specific shapes and edges.

**Cristofle, Place Vendôme**
**Catherine Brennand**

34 × 37 cm (13 ½ × 14 ½ in)
Watercolour on 400 gsm
(200 lb) Not paper

**Step 2**
The painting developed into a combination of careful painting and expressive techniques. It takes a brave painter to leave areas to the viewer's imagination – notice, for example, the boldly painted bottom right-hand corner, and the top section of the painting. These wonderfully surprising areas of texture add another 'layer' of interest to the image.

Catherine used a roller to apply loose grey and gold broken washes of colour to the paper before starting any detailed work.

The pillar was painted directly over the top of the initial washes. The warm gold used for the brickwork provides just enough colour interest to enliven the grey paint used for the architectural element.

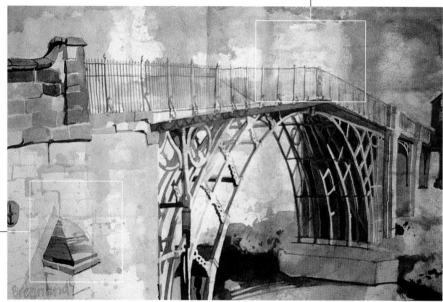

**The Iron Bridge**
**Catherine Brennand**

37 × 55 cm (14 ½ × 21 ½ in)
Watercolour on 400 gsm
(200 lb) Not paper

# The Iron Bridge

The first iron bridge in the world was built in Shropshire in 1779 in order to transport ore from the coal mines for smelting iron. Its builder was the industrialist Abraham Darby III, who was also a clever businessman. He commissioned an engraving of the construction, which was then printed and sold to raise money. The engraving went through several editions, such was the interest in the new iron bridge.

There is a very 'English' feel to this painting, partly because of the almost monochrome colour, reminiscent of the cool British climate, which is used by Catherine as a reflection of the industrial element of the subject. The method of painting also owes something to the early English watercolourists – a slow, careful build-up of washes, until the required depth of tone is achieved, coupled with excellent draughtsmanship. However, the painting is given a touch of Brennand liveliness, with the addition of more freely applied passages 'beneath' the more considered areas of painting and drawing.

# PROJECT • Experiments with collage

Collage gives the artist the opportunity to experiment with a variety of new surface textures, depending on the materials you use. Oriental papers with visible fibres provide one kind of texture, while sheets of plain tissue, or torn strips of watercolour paper, give completely different effects. The amount of adhesive used and the evenness of application will also affect the quality of the surface.

## Effects with paper

It is possible to collage onto unpainted paper or over existing coloured areas, so that the previous washes of colour show through the collaged papers.

For these early experiments concentrate on how it 'feels' to work on a variety of collaged surfaces. Apply torn pieces of Japanese fibre papers in a random manner; you can include other collage materials, such as newsprint, labels, or torn coloured paper. Use PVA glue diluted with water to the consistency of thin cream. Then paint the surface of your paper with the diluted adhesive using a stiff bristle brush, and apply the torn pieces of paper, using the same brush, but without adding more glue – this will allow for successful overpainting.

When the collage is dry, overpaint with watercolours, acrylics or gouache. The colour will automatically help to create a cohesive image, but do begin to consider composition as you work.

See the difference in effect when you make a stroke with a brush fully loaded with fluid watercolour, and then make another stroke with an almost-dry brush. Try spattering colour; try linear strokes with a thin brush. Apply another layer of collage in places, and observe the effect. Brush diluted white gouache over a painted area and observe the difference between opaque oriental paper and diluted white gouache. You can take your experiments one step further, if you wish, by introducing more linear work, using pencil, ink, crayons, or pastels, taking advantage of the linear fibres in the collaged papers. Combining line and texture in this way may well open a door for you to more expressive images.

### Collage Creation
**Jackie Simmonds**

21 × 29 cm (8½ × 11½ in)
Collaged practice sheet, with
tissue and Japanese papers
overpainted with watercolour.

# Light and atmosphere

## Roger Dellar

Roger is an elected member of a number of prestigious UK art societies, including The Royal Institute of Painters in Watercolours. He has won many awards for his work, including the Royal Watercolour Society Abbott and Holder travel award in 2000. He is a figurative artist, who not only works in watercolours, but also in oils, pastels, acrylics, and other water-based media. He regularly exhibits his work in galleries throughout the UK, and in the USA. Roger is also in much demand as a teacher and runs courses throughout the UK, the USA and Europe.

## An unconventional approach

Roger works with watercolours in a most unusual way, although he stresses that his approach is an on-going process of exploration. For now, he completely disregards all watercolour conventions, and treats watercolours exactly as he treats all other mediums, concentrating on the demands of the image. In Roger's hands the paint is pushed and pulled on the surface; loosened, softened, overpainted, glazed, and worked-into, time and again. Unlike conventional watercolour painting, the 'lights' are not reserved – instead, Roger builds up the image with medium and dark tones, bringing the light areas in gradually, and as needed, with opaque pigments. His watermedia paintings are a mixture of watercolour and gouache, often with the 'weight' of an oil painting, yet with passages of velvety wet-into-wet softness in places.

Roger working outdoors with an extended brush, which allows him to keep his board a little further away from him and also eliminates the need for an easel.

Often, Roger paints outdoors. At other times he produces his final image in the studio from sketches or photos. If a photograph, or a group of photos, is used he makes initial sketches in paint or pencil and then paints from the sketch rather than from the photographs. Sometimes he starts a painting simply with colour, 'pushing it around' until a subject appears. He says, 'sometimes I will see in nature a collection of patterns and shapes – part of something recognizable, but out of context – and it will motivate me in a direction'.

## Materials and palette

Roger occasionally uses water-soluble crayons, conté crayons, and pastels, together with his watercolours, gouache and acrylic paints. He likes to work on Saunders Waterford 640 gsm (300 lb) paper, with a large variety of art and household brushes. He often uses hog-hair oil-painting brushes instead of soft watercolour brushes, and in the studio clips his paper to a board at an easel in a fully vertical position – a practice seldom seen in a conventional watercolourist's studio. Outdoors he sits on a small stool, his painting gripped between his feet and propped up on a bag, using a brush extended by a hollow bamboo tube.

Most watercolourists work at a table, keeping their board flat, or slightly tilted, in order to control the flow of the paint. Unusually, Roger works indoors at a studio easel that is completely upright.

# Techniques

Roger feels strongly that each image develops organically, and he responds very much to the needs of the painting, working instinctively rather than carefully selecting a specific technique in order to achieve a particular effect.

Nevertheless, it is clear that the artist is well aware of the differences between the opaque materials he uses, and the transparent ones. He capitalizes on these differences, being careful to ensure that his layers of pigment are considered in order to enhance the effectiveness of the image. He uses additional materials – water-soluble crayons and pastels, for instance, or the wrong end of the brush – in order to create calligraphic marks, texture and interest.

**MIXED MEDIA**
Water-soluble crayon was used here over dry washes of watercolour paint.

**DRY-BRUSH HATCHING**
Using hog-hair brushes instead of soft sable watercolour brushes makes it easier to achieve a dry-brush technique. Dry-brush work, some of it cross-hatched, was used here with opaque paint over transparent watercolour to create texture and depth.

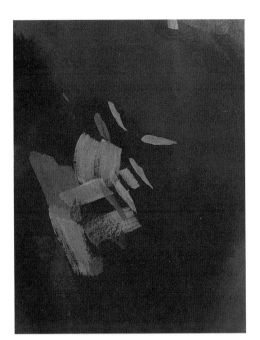

## MARK MAKING

A variety of marks can enliven a painting. Dots and dashes of opaque colour were applied here over a dark watercolour wash.

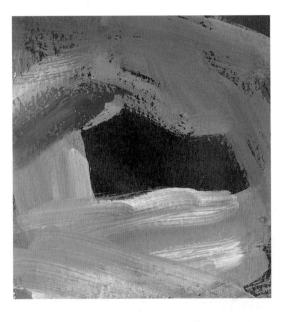

## CUTTING IN

In order to 'reveal' a particular shape in a painting, it helps to 'cut in' around a shape, with opaque pigments.

## Artist's Secret

Invest in a large mirror, ideally hung or placed behind you in your studio. When you are unsure about the progress of a painting, simply turn around and look at the painting in the mirror. Immediately you will notice areas of composition, design, tone and colour, that require adjustment.

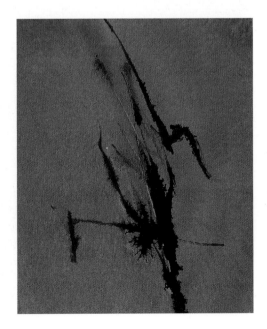

## CALLIGRAPHIC MARKS

The 'wrong' end of a wooden paintbrush was dipped into ink to make interesting calligraphic marks on an almost-dry watercolour wash. The mark achieved depends on the amount of ink on the end of the brush, and the wetness of the wash. Ink often 'bleeds' into a surrounding damp area.

It is easy to see from Roger's demonstration thumbnail sketch that he concentrated on the overall pattern of light and dark shapes within the rectangle, and the dynamic angles of the composition.

# The Cellist

Roger never begins with an outline drawing. Each of his paintings begins with a loose pattern or design, and when the design starts to develop into a strong composition only then does he allow himself the luxury of bringing in more recognizable, figurative elements.

In this painting the facial features are impressionistic, but not at all random. Because of the deft placement of the marks, the concentration of the musician is clear to see. Small brushstrokes of dark watercolour and cool, opaque, light pigments were applied over the initial warm watercolour washes, which perfectly described the solid three-dimensional form of the head with light, medium and darker tones. There are no hard edges on the arm and body that might attract too much attention away from the face.

**The Cellist**

**Roger Dellar**

34 × 29 cm (13 ½ × 11 ½ in)
Watercolour and gouache on
Saunders Waterford 700 gsm
(330 lb) Not paper

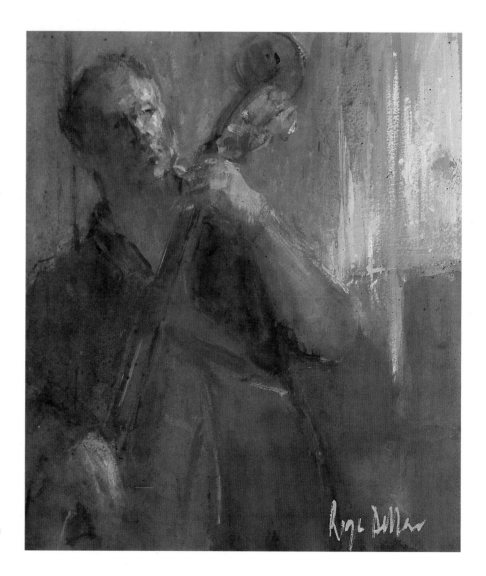

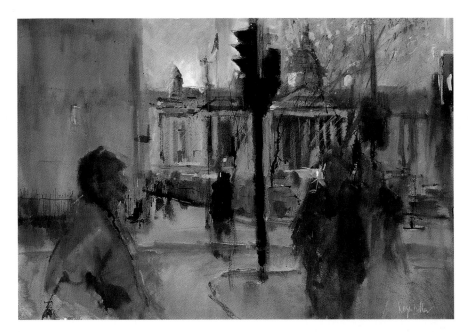

**Towards Dusk, Trafalgar Square**

**Roger Dellar**

42 × 64 cm (16 ½ × 25 in)
Watercolour, gouache, black
ink and watercolour crayon on
Saunders Waterford 640 gsm
(300 lb) paper

# Towards Dusk, Trafalgar Square

This fresh and spirited painting was painted from
one of a series of sketches made on the spot late
one afternoon in London's Trafalgar Square. The
evening light warms the grey stone buildings,
and Roger's bold use of speedy calligraphic marks,
and loosely suggested shapes for vehicles and
figures, perfectly captures the hustle and bustle of
this square, with its endless lines of roaring traffic
and preoccupied pedestrians.

Roger used watercolour for the important cool
area on the left of the painting. This relates to the
blues elsewhere in the composition, providing a
marvellous counterpoint to the warmth of the
pinks, reds and blacks elsewhere. The wash was
varied by the addition of several layers, worked
wet-into-wet. Black ink was used for the structure
of the building, suggesting the pillars and their
dark recesses. The calligraphic lines were made with
the 'wrong' end of the brush, loaded with black ink,
which bled into the wet layers beneath, creating the
slightly out-of-focus effect.

Roger made several sketches
to help plan his final
composition. Sketches from
different viewpoints allowed
for variation in emphasis.

## Henley

**Roger Dellar**

25 × 30 cm (10 × 12 in)
Watercolour and gouache on
Saunders Waterford 640 gsm
(300 lb) Not paper

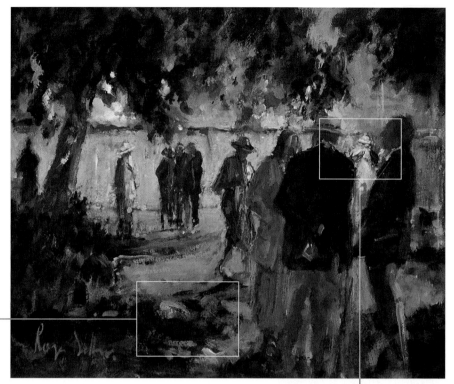

Dark shadows were painted
with thin washes of
transparent pigment, and
the lighter, sunlit areas were
then 'cut into' the darks.

Dots and dashes of opaque
colour suggest movement and
activity in the distance between
and beyond the dark shapes
of the foreground figures.

## Henley

Roger has a great interest in observing people in their environments and he
particularly enjoys capturing the special light of a certain moment in time. This
painting was produced in the studio after a glorious summer's day at Henley
Royal Regatta, where rules of protocol are strict and Roger was only allowed to
make sketches and take photos on the spot. The regatta has been an important
social summer occasion in the UK for over a century. In certain areas there is a
'dress code' – blazers and boaters for the men, and beautiful clothes for the
women, who must ensure that knees are covered or entry is barred!

Although this is a watercolour and gouache painting, it has the look of a fully
worked oil painting. The darks are rich and velvety, the lights are thick and
impasto. The image was slowly developed, built up with direct and lively mark-
making in an impressionistic manner, and this adds to its life and movement.

# South Bank

London's South Bank of the River Thames is a wonderful resource for painters, with trees lining the embankment, beautiful buildings across the river, and pedestrians and cyclists galore. There are seats along the embankment, providing sketching artists with a comfortable spot to sit.

This is an unusual composition, with its deep foreground shadow boldly slicing across the rectangle. However, what could have been a rather monotonous area of shadowed grey pavement has been reinvented by the artist and is full of texture, life, warmth and variety.

**South Bank**
**Roger Dellar**

30 × 25 cm (12 × 10 in)
Watercolour and gouache on
Saunders Waterford 640 gsm
(300 lb) Not paper

Roger used 'optical mixing' for his painting of the trees – touches of reds and greens, yellows and blues suggest, and 'read' as, foliage.

The lively texture of the shadow was achieved with 'paint cross-hatching' – colours were stroked over each other, exactly as you might cross-hatch with pastels. Warms and cools in similar tones were woven together, creating an active, varied area of colour. Opaque lights were added last, over dry areas of darker tone.

# Evening Rush Hour, Battersea Park Road Bridge

Roger likes to try to capture the atmosphere of London and he enjoys the challenge of tackling the older, shabbier areas. Battersea Park Road Bridge would not be the first choice of most artists – it is dark, grimy and colourless. But not to this artist's eye. He builds up his compositions with glaze after glaze of transparent watercolour, using complementary colours to create, and enrich, those dirty London greys. In this atmospheric composition dark greens melt into deep, velvety maroons; in the middle tones, subtle ochres, grey-pinks and grey-purples can be discovered. Early watercolour washes were modified and softened with subsequent layers of opaque body colour.

**Evening Rush Hour, Battersea Park Road Bridge**

**Roger Dellar**

56 × 76 cm (22 × 30 in)
Watercolour and gouache on Saunders Waterford 640 gsm (300 lb) Not paper

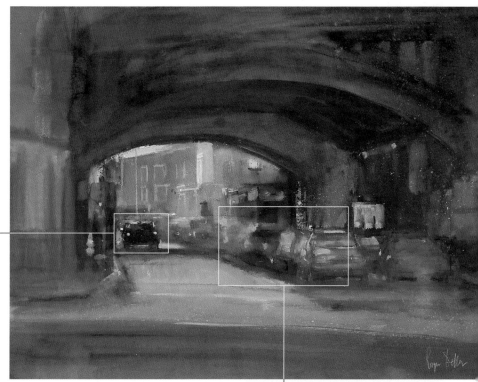

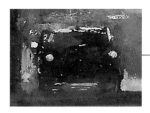

Opaque body colour was used for the car headlamps and shiny roof. The only alternative to the use of body colour would be to reserve the colour of the paper with masking fluid. This would require specific forward planning, which would not be in keeping with Roger's fluid, push-pull approach.

Opaque body colour was washed over the earlier dark watercolour shapes to create a visual 'blend' in this area, suggestive of the movement of the line of cars.

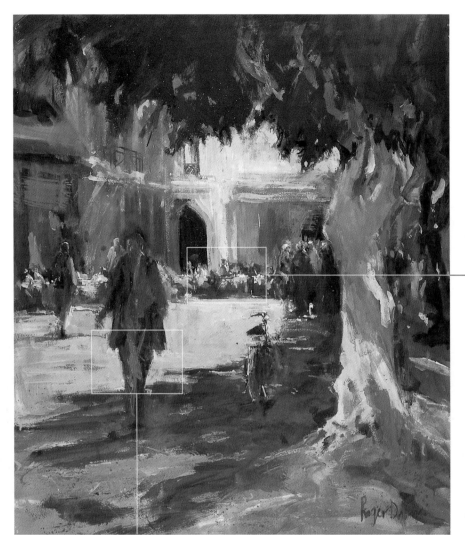

**Lunchtime, Essaouira**
**Roger Dellar**

62 × 55 cm (24 ½ × 21 ½ in)
Watercolour and gouache on
Saunders Waterford 640 gsm
(300 lb) Not paper

Gestural marks made with
a small brush denote the
people at the café, using thick
dabs of opaque gouache
over broader areas of dark
watercolour. These tiny
strokes 'read', from a distance,
as figures at sunlit café tables.

Opaque gouache in light tones was used to 'cut in'
around the dark mass of the figure, defining the
shape. The light-coloured gouache was applied
loosely over a dark wash, allowing some of this
previous watercolour wash to show. This activates
the sun-washed ground area of the square.

## Lunchtime, Essaouira

Essaouira is a busy coastal town in Morocco. This particular square is always
a cosmopolitan mix of locals chatting in groups, in their timeless long woollen
'djellaba' robes and white skull caps, and tourists in modern garb strolling
through the square and watching the activity from café tables. This ancient tree,
with its peeling whitewashed trunk, casts long, deep shadows across the
brilliantly sunlit square. Roger developed this painting in his studio from a
series of sketches and back-up photographs taken in the square.

**Saturday Market, Chania**
**Roger Dellar**

20 × 25 cm (8 × 10 in)
*Watercolour and gouache on*
*Saunders Waterford 640 gsm*
*(300 lb) Not paper*

# Saturday Market, Chania

This image was painted on the spot, a board clamped between Roger's feet. Painting in a busy market is a challenging task for any painter; it requires the ability to quickly understand and distil an ever-changing scene, while retaining the atmosphere of the place and strength in the composition. It is also important to find a spot where there is some shade on a hot day, and where your outstreched legs will not trip up passsers-by or annoy stallholders!

Roger blocked in the main compositional shapes with transparent washes of watercolour, and then, as the paint gradually dried, he began to introduce the shapes and forms of the people, market stall and umbrellas, using a mixture of shape and line. The initial watercolour washes were activated with layers of splatter, and cross-hatched with opaque pigment. There is the freshness and immediacy of a sketch in this little watercolour, which is difficult to replicate in the studio without the adrenalin charge of working fast.

# Tango 1

Roger watched a tango lesson and took a series of photographs, but they froze the movement, and failed to capture the atmosphere. So he relied on his memory and imagination for the paintings, which enable us to see and feel everything that the camera failed to record – the blurred twisting moves, the figures melting into their surroundings, the heat of the moment and dark drama.

Roger started with the darks, the upper half of the picture merging with the moving forms of the figures. Then the middle tones were added, working the paint wet-into-wet, to find the forms. Roger used oil painting brushes, with the paper upright on the easel. As the surface began to dry he started to use opaque pigments, 'cutting in' against the dark shapes, defining the figure in places, allowing the paint to drift into the form in others, to maintain the sense of movement. Finally, tiny marks, made with the smallest of brushes, suggested the sparkles of light on the dancers' heads.

# Tango 2

The second painting was painted with acrylics, which dry fairly quickly and are not so 'fluid' to work with. This suited Roger's purpose since he wanted to achieve a sense of stillness as the figures wait to begin the dance. Again, tiny touches of white, and brilliant red, were the last marks to be applied, bringing certain important areas into focus.

In both paintings the figures are little more than simple flat shapes. Yet, despite the lack of detail, we fully understand the figure dynamics – the raised shoulders, the twisting hips, the distribution of weight down through the figure. This kind of authenticity can only be achieved by the artist who truly understands the human form.

**Tango 1** (above)
**Roger Dellar**
32 × 27 cm (12 ½ × 10 ½ in)
*Watercolour and gouache on Saunders Waterford 640 gsm (300 lb) Not paper*

**Tango 2** (below)
**Roger Dellar**
32 × 27 cm (12 ½ × 10 ½ in)
*Acrylics on Saunders Waterford 640 gsm (300 lb) Not paper*

# Bold
# impressionism

## Terry McKivragan

After some years running his own graphic design studio, Terry McKivragan left the commercial world to concentrate on watercolour painting. His paintings have won numerous awards; he is a member of the Royal Institute of Painters in Watercolours and is an RI Medal award-winner. Initially, he worked with watercolour and gouache, inspired greatly by the watercolour paintings of J. M. W. Turner (1775–1850), but now he generally uses acrylics, a medium that he finds lends itself to a more impressionistic, bold technique, and allows him to explore the use of interesting textures.

## Drawing and painting combined

Drawing is very important to Terry; he likes to have a strong underpinning of solid draughtsmanship in his paintings. He also firmly believes that painting is about the use of paint qualities – quite the opposite, he feels, from a photographic approach. He does his best to move away from absolute realism by adjusting composition and colour, and losing detail eventually in favour of texture in an attempt to capture the excitement of a more abstract element in the painting.

Terry prefers the word 'balance' to 'composition'. His paintings often use the element of a strong horizontal to achieve this sense of balance, and the placement of the horizontal line is carefully considered for dramatic impact. He enjoys painting water scenes because of the natural horizontal provided by

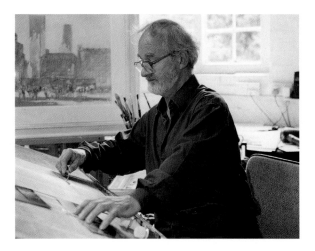

Terry at work in his studio. He likes to work at a draughtsman's table, his board at a slight tilt.

water in the landscape, and the contrasting vertical elements in the form of reflections. He uses a combination of subtle colour, pattern, texture and drawing to achieve his remarkably atmospheric compositions.

For the main painting Terry draws the essential elements fairly accurately, even though he knows that in the later stages much of the drawing will disappear. This firm initial structure, however, controls all subsequent work, enabling him to loosen up and allow the paint to create interesting shapes and textures, giving movement to the figures and adding atmosphere to the painting.

## Materials and palette

Terry generally works on prepared hardboard for his larger paintings, or white mountboard for smaller pieces. The mountboard is left unprimed, as the initial washes act as a primer. He uses acrylics like watercolours first, then like body colour, often straight out of the tube. Terry feels that the vitality of his paintings depends on this mixture of transparent passages and opaque acrylic effects.

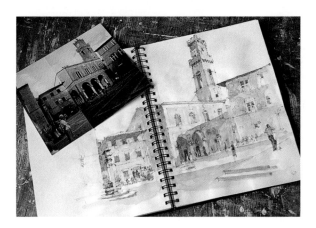

Terry often backs up his 'working sketchbooks' with reference photos, which can provide additional information if needed.

# Techniques

Terry's techniques are a mix of those of the traditional watercolourist – using brushes for both transparent and opaque glazes – and those of the oil painter, since he sometimes resorts to the use of a palette knife for impasto, opaque, textural effects. Drawing is often featured in his work, and the use of pencil or pen work adds another dimension.

The techniques he has developed depend for their success on an understanding of the surfaces he uses. He does not often use watercolour paper; if he did, the techniques might well differ in effect. When developing an unconventional approach to water media painting, it is important to realize that the surface plays its part in the finished effect.

**WARM OVER COOL**
Dilute cool blue acrylic paint was washed broadly onto white mountboard. When dry, more dilute paint was applied over the top, this time using a much warmer colour.

**GLAZING**
A dilute blue wash was applied first, which granulated, giving a subtle textured effect. Then, opaque acrylic was used for more solid shapes and, finally, on the left-hand side, a layer of very dilute Yellow Ochre was washed over the top as a warm glaze. This has a binding effect.

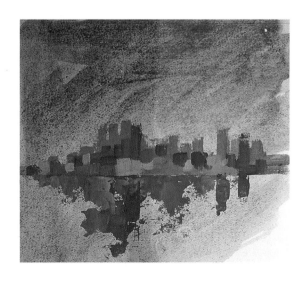

## MIXED WASHES

Initial washes of very dilute acrylic paint were washed onto mountboard, using a mixture of French Ultramarine and Alizarin Crimson. The land features were applied using thick, opaque pigment.

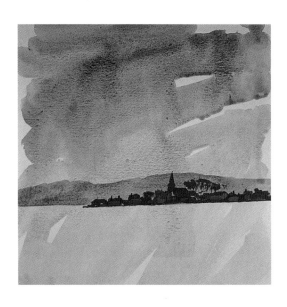

## PALETTE KNIFE TEXTURE

Over transparent washes it is possible to create textured marks by applying opaque paint with a palette knife. This gives random effects, so do take time to practise.

## LINEAR DRAWING

The pencil drawing was created first, followed by broad transparent washes of a warm tone. More opaque passages of paint were then applied in specific areas. Some of the pencil lines were 'sharpened' with the use of a pen dipped in acrylic paint.

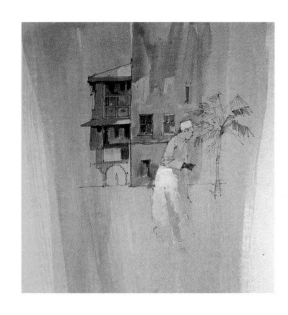

# Painting in progress

Terry usually starts with a fairly accurate pencil drawing, picking out some lines with pen and acrylic paint. He then uses a big brush with plenty of watered-down acrylic paint, and applies the paint freely, allowing it to create its own textures. Once these initial washes are dry, further washes are added to establish the main areas of colour. In the final stages Terry often uses paint straight from the tube, sliding it onto the painting with a palette knife.

Terry joined his location photographs together to provide a more complete panoramic view of the scene.

**Step 1**
This shows the initial 'underdrawing' in pencil on white mountboard. Much of a drawing's detail may disappear eventually.

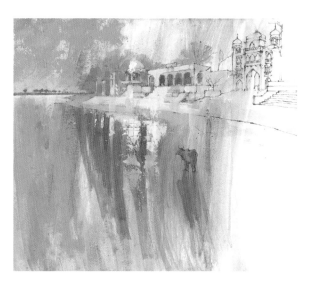

**Step 2**
After the drawing stage transparent washes of blue and yellow were broadly applied with a large mop brush. Then, some of the drawing was restated with a pen dipped into acrylic paint – as in the top right-hand corner. Opaque passages were applied – sometimes with a brush, where specific shapes were needed, and in some places with a palette knife for more abstract textural effects.

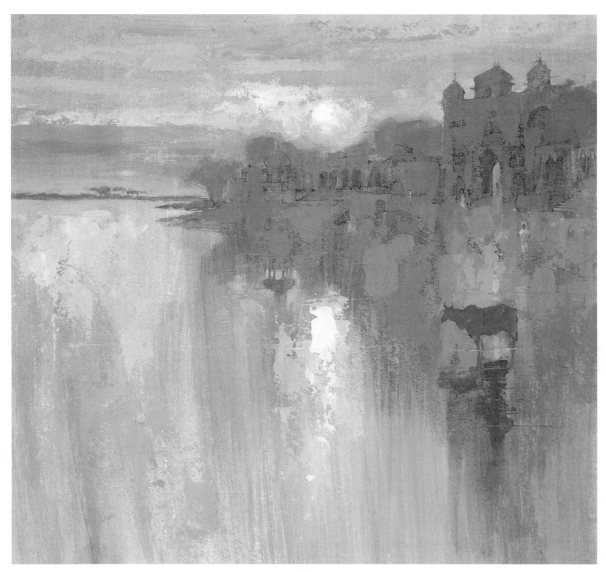

**Step 3**

The final painting displays a different time of day, and a different light effect. It has a wonderfully ethereal atmosphere, achieved through the use of subtle colour mixes. Much of the early drawing has disappeared under the semi-abstract passages of opaque pigment, although the transparent vertical washes are still apparent in the foreground. Horizontal bands of opaque texture at the top of the picture describe the sky, while counterbalancing the strong downward pull of the vertical strokes in the lower half of the image.

**Evening Light, The Lake, Jaisalmer**

**Terry McKivragan**

34 × 38 cm (13 ⅜ × 14 ¾ in)
Acrylic on acid-free mountboard

# Window Chat, Havana

Architectural subjects have always fascinated this artist, and Terry travels widely for his source material. However, he began to feel that relying on just the architecture to capture the character of a country was missing a point. So, recently, figures have started to appear in his compositions as a foil to the architectural detail, and to project a more rounded image of a country. This painting shows an architectural façade that is dependent for its interest on two main elements – geometric shapes and colour.

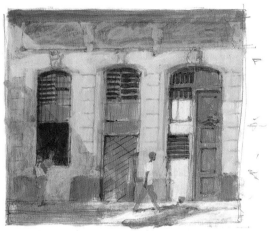

The location photograph shows a very pale turquoise building, with a wealth of detail and unusually high doorways and windows. The vertical elements are offset by horizontal banding top and bottom, and a strong diagonal shadow provides variety and interest.

Although the pencil sketch at the bottom relates closely to the photo, the colour sketch shows that the artist decided to use only the central section. Notice, too, the figure that is walking; this disappears from the finished painting.

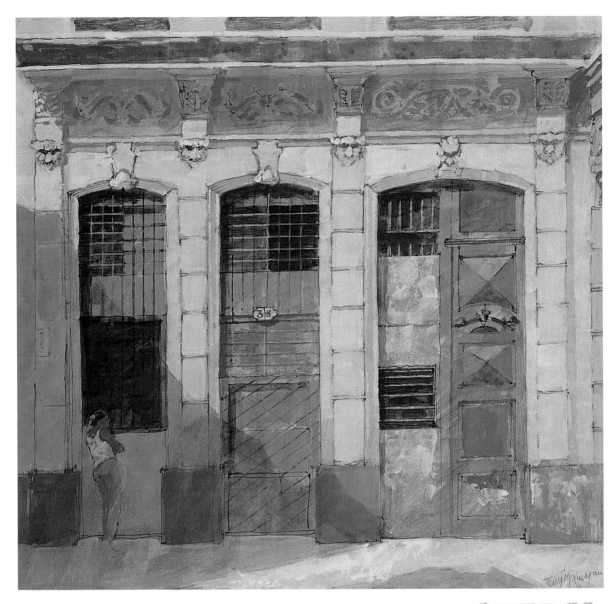

### Window Chat, Havana

**Terry McKivragan**

36 × 38 cm (14 × 15 in)
Acrylic on acid-free
mountboard

The artist felt that the colour
could be exaggerated for
more impact, so the blue of
the building has become
stronger. The figure standing
chatting in the picture, and
the second one hidden in the
window, add a subtle touch
of life to the building, hinting
at local lifestyle.

## Artist's Secret

In order to paint straight
lines first draw a grid
effect carefully in pencil.
Then use the edge of a
2.5 cm (1 in) straight wide
brush to give a thin line
with a bit of character.

# Painting in progress

Terry's preference is to sketch on location, and then work on the final painting back in the studio after developing his ideas about the subject through a series of small experimental sketches. These sketches explore design, colour and textural possibilities, and they often depart from reality in order to emphasize drama and atmosphere. Terry feels that these exploratory sketches are essential in order to make creative decisions, and resolve problems, at an early stage.

This is a wonderful example of what can be achieved with a subject that most of us would pass by with hardly a second glance. However, an artist often finds poetry in just such material. In this case, the title of the piece shows what inspired the artist. Photographs of the scene provided back-up material, and at home in the studio Terry produced a small compositional sketch to explore the subject.

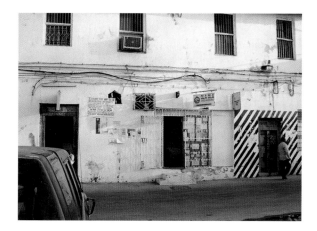

**Step 1**
Terry was struck by the geometric patterns in the scene – strong horizontal shapes, diagonal banding and shadows, echoing angles and triangles.

**Step 2**
The figure was taken from this photograph, and in the sketch can be seen providing a strong, light focal point against the dark of the doorway. The shape of the figure helps to link the top of the picture with the horizontal band of the roadway.

**Step 3**
A small preliminary sketch helps you to clarify your ideas. Here Terry has deliberately subdued colour in favour of pattern, and the placing of the figure has been carefully considered.

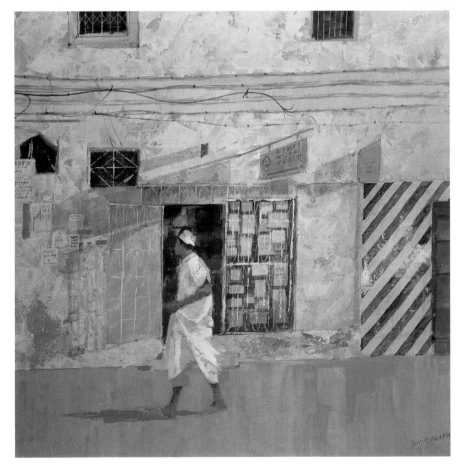

**Step 4**
The peeling whitewash of the building was achieved with thick acrylic paint applied with a palette knife. When this was dry, subtle layers of transparent acrylic in the form of a 'watercolour wash' were used as a glaze to create the shadows on the building. Details like the electrical wires and the bars on the windows were added with a pen dipped in acrylic paint.

### Zanzibar Patterns
**Terry McKivragan**
41 × 39 cm (16 × 15 ½ in)
Acrylic on acid-free mountboard

# The Painters, Rhajastan

This painting is an excellent example of how acrylics may be used in a watercolour manner, with just a few opaque painted or palette-knife passages. The figures are integrated into the composition so that they do not dominate the scene. In fact, the dark shapes of the camels, set against the sun-drenched buildings behind them, attract attention initially and the figures reveal themselves to us gradually. The painting has all the liveliness of a sketch executed quickly on the spot; the underpinning of good drawing is offset by bold, vigorous painting and clever linking of paint passages.

**The Painters, Rhajastan**

**Terry McKivragan**

23 × 24 cm (9 × 9 ¼ in)
Acrylics on *acid-free mountboard*

The painter was drawn swiftly in pencil – but notice that only part of his clothing was picked out with opaque white pigment. This integrated his figure with the warm light tones around him, allowing the wedge-shaped area of light in the composition to retain all its importance.

Watery washes of acrylic were washed swiftly across the sky, with diagonal slashing marks that activate the large negative shape, and counterbalance the directional strokes used in the shadow at the bottom of the image.

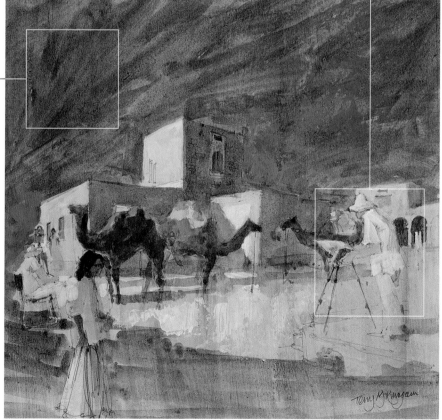

## Fort Entrance, Jaisalmer

**Terry McKivragan**

25 × 66 cm (10 × 26 in)
Acrylics on acid-free
mountboard

Executed with boldness and panache, the original warm washes of dilute Yellow Ochre were applied with a wide brush from top to bottom of the image. This is a warm undercolour that modifies all subsequent applications of cooler colour.

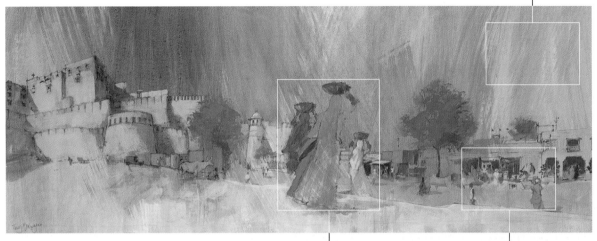

The figures were carefully drawn initially, and then thick pigment was applied in a dry-brush fashion, allowing the drawing to show through. The figures are not 'coloured-in', which would give a cut-out effect – the dry-brush texture effectively 'knits' the drawing with the rest of the image.

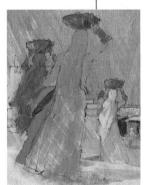

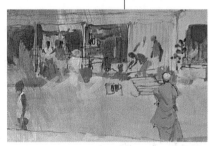

Dots and dashes of colour were used to suggest the activity around the small shops.

# Fort Entrance, Jaisalmer

This painting shows clearly Terry's passion for drawing combined with his exciting painting techniques, executed with boldness and confidence.

An unusual format, long and wide, was used for this dramatic composition. The buildings were carefully drawn, and the addition of figures and animals gave busy life and interest to the scene. Bold use of colour in the sky is offset by smaller touches of strong colour across the horizontal band of buildings, and tiny touches of red and gold attract the eye and encourage the viewer to read 'across' the image. Notice how the use of dramatic differences of scale in the figures adds to the sense of depth in the painting.

# Exotic
# inspirations

## Laura Reiter

Laura has a BA (Hons) degree in Fine Art, together with a Master's degree in Printmaking, and is an Elected Fellow of the Royal Society of Painter Printmakers. She has won many an award as a printmaker, but more recently she has been concentrating on her painting, and her work in this area has also won a number of awards. One of the most important of these, in 2003, was from the Royal Watercolour Society.

## Colour and imagination

Laura's vibrant pictures utilize both painting and printmaking techniques, and they are often inspired either by ancient history and mythology or by her travels to exotic locations such as Mexico, India, Japan or Morocco. She learns the stories, markings, drawings and patterns that are an intrinsic part of the culture of the land. She also brings home objects, and these objects either appear in her work or they are used to fire her memories. Laura's paintings change and evolve as she responds to her source material, memories and feelings – she considers each painting a 'visual landscape and inventory'.

Laura also enjoys the challenge of finding the balance between 'unplanned' beginnings and a structured conclusion when she begins a piece entirely intuitively, using colour and gestural marks alone as her starting point. To develop a painting from such a beginning requires a willingness to 'free-fall'

Laura places her table against a window in order to capture natural daylight. She often works flat so that she can pick up her board and tilt it to create interesting effects with initial transparent washes.

Laura's favourite out-of-the-ordinary colours include:

Caput Mortuum Violet (watercolour)

Cobalt Turquoise (watercolour)

Cobalt Violet (watercolour)

Winsor Violet (watercolour)

Green Gold (watercolour)

Bengal Rose (gouache)

Medium Magenta (acrylic)

Acra Red Orange (acrylic)

Dioxazine Purple (acrylic)

Bright Aqua Green (acrylic)

Brilliant Purple (concentrated liquid acrylic)

Raspberry (concentrated liquid acrylic)

Maroon (concentrated liquid acrylic)

into improvisation, something our ordered human minds often find quite difficult. Laura has learned to trust her inner creative self as she allows herself to become involved in a world of colour and imagination, sometimes finding a subject after the painting is almost completed. It takes bravery, and confidence, to work in this way.

## Materials and palette

Laura uses both watercolour and acrylic paints for her work, together with other 'mixed media' – acrylic inks, collaged papers, acrylic texture gels, metallic powders and flakes in an acrylic polymer emulsion, and oil and chalk pastels. She usually works on Bockingford 300 gsm (140 lb) paper, beginning with transparent watercolour and inks, and gradually she switches to acrylics, enjoying the contrast of opaque passages with transparent ones. Laura also works on canvas with acrylics, trying to use them in much the same way as she might work with watercolours – beginning with a traditional, loose, watercolour wash approach, but then gradually building up the painting with layers of more dense, opaque marks. She uses synthetic brushes and works flat at a table.

### Little Horse, Magic Stones
**Laura Reiter**

53 × 67 cm (21 × 26 in)
Mixed media on 300 gsm (140 lb) Not watercolour paper

Laura began with lots of watercolour washes, dividing the rectangle to make a very strong asymmetrical composition. The horse is an actual object, a small roughly carved wooden animal in the artist's collection.

# Techniques

Laura is a very experimental painter, and loves to develop new techniques all the time. Her studio is an Aladdin's cave of paints, inks, pastels and crayons of all kinds. She also continuously collects materials and implements to extend the variety of her mark making, such as interesting sticks, unusual brushes, sponges, stamps, and a variety of collage papers. Laura enjoys the unpredictability of watercolour, and she capitalizes on the unexpected happenings that often occur as a result of free, uninhibited experimentation. However, her work does not stop with transparent effects. She moves from transparent layers to more opaque ones, aiming for spontaneity and freshness all the time.

### MIXED MEDIA

Laura collaged turquoise paper over a dry wash of pink. When dry, she painted over the top with turquoise acrylic paint. She added a further layer of thick acrylic, which she 'drew into' with the end of a brush. Finally, she added a pale green stripe of wax crayon.

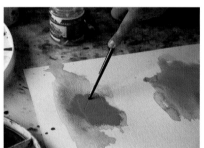

### STENCILS AND STAMPS

This piece shows a wet-into-wet wash, and marks made with small hand-cut 'stencils'. Laura often creates stencils and stamps, sometimes cutting a shape into an eraser or sometimes using found objects.

**MIXED TECHNIQUES**

In this practice sheet Laura used tissue collage, which was then overpainted. There is an area of wax resist (bottom centre). Calligraphic marks were made with both a green water-soluble crayon and a graphite pencil. Rock salt was dropped into a wet watercolour wash in the top-left corner.

**MARK MAKING**

This practice sheet was for a gardens/landscape workshop. Tissue collage was applied over loose watercolour washes, and pink and red marks were made with chalk pastel. White acrylic was dry-brushed on and, when dry, overpainted with watercolour. Black calligraphic marks were Indian ink, applied with a sharpened bamboo stick.

# Japanese Angel

This image was inspired by Laura's visit to Japan, and a small saucer she bought that was decorated with an angel-like geisha girl. The colours – hot reds, pinks and oranges – reminded Laura of the colours she saw on her trip and there are references to Japanese flowers to be found within the image too. The first layers of colour were the yellows and greens, which were loose watercolour washes, left virtually untouched on the left-hand side of the image. Laura likes to 'play with paint' at first, and then the image 'grows' out of her subconscious as well as her conscious thoughts, and gradually the composition develops strength.

**Japanese Angel**
**Laura Reiter**
44 × 53 cm (17 × 21 in)
Mixed media on 300 gsm
(140 lb) Not watercolour paper

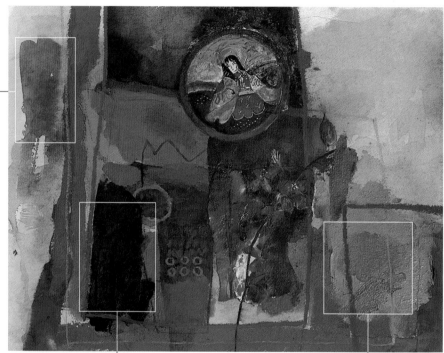

Early washes of brilliant yellow and green watercolour, painted wet-into-wet, were left to be quite transparent, and 'behind' subsequent layers of opaque acrylic paint.

A dense dark area was created at the bottom of the image to balance the dark shape at the top. A piece of coloured paper was collaged on with PVA glue, then overpainted with dense acrylic paint. The underlying paper gives this area a slight texture.

To achieve a feeling of texture Laura collaged with some tissue paper, which was then overpainted with turquoise acrylics. The pink line, which behaves like a resist, was achieved with oil pastel.

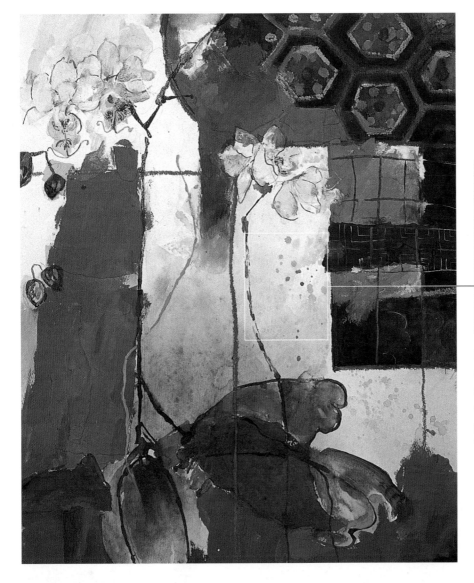

In this area you can see the early washes of pale lemon and green watercolour. The area is activated, however, with green spattering, done while the initial wash was still damp.

# Orchid Drama

Laura saw an orchid plant and fell in love with it. Orchids have an eastern, oriental nature, so Laura felt that her picture had to have that kind of reference to its origins. She looked at patterns of Japanese screens and took patterns from origami paper. She particularly likes the fact that the image 'goes back', enjoying the subtle illusion of receding space. The watercolour areas seem to sit behind subsequent layers, reminiscent of Japanese sliding screens.

An oil pastel was used to draw the pattern in the top right area. Washes of colour over the top were resisted by the oil pastel, and Laura built up the pattern using either light or dark opaque pigment for the final details.

**Orchid Drama**
**Laura Reiter**

67 × 53 cm (26 × 21 in)
Watercolour and mixed media on 300 gsm (140 lb) Not watercolour paper

# Silver, Flowery Box

This image was inspired by a small silver box from India, decorated with coloured stones, and also autumn garden berries, which reminded the artist of the box's decoration. Laura's creativity is often stimulated by found objects.

The central section consists of initial watercolour washes, which Laura often tries to hold on to as much as possible. She used Japanese papers for collage in this piece, enjoying the texture they provided. She wanted big contrasts in tone, which gives a sense of the objects being contained in their own spaces. In the darker areas of the picture the items within the dark shapes are less obvious, but Laura feels this makes them seem more 'precious' and important. The image, begun with watercolours, was developed with oil pastels and with layers of acrylic paint, both transparent and opaque, over the top.

Pen and acrylic ink was used in this area, over the initial wash of brilliant pink. Laura rewetted the area, which encouraged the ink lines to bleed inwards.

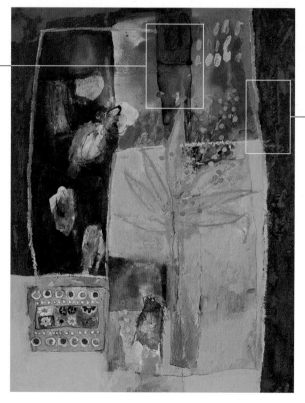

**Silver, Flowery Box**
**Laura Reiter**
67 × 53 cm (26 × 21 in)
Watercolour, acrylic and collage on 300 gsm (140 lb)
Not paper

The panel of texture running down the side of the rectangle was created by heavily worked oil pastel, scribbled over a brilliant pink initial wash. More washes of colour were added over the top of the oil pastel, until the final effect was achieved.

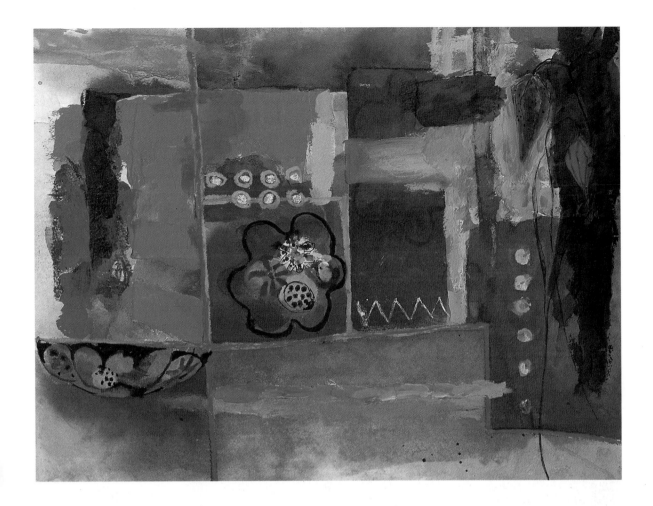

## Roz's Lovely Wavy Bowl

The inspiration for this piece was simply a friend's ornamental bowl with an unusual wavy edge. Laura started with what she calls her 'wiggly wash' – wet-into-wet watercolour, tilting the board to mix the colours. She frequently begins in an abstract way, with a coloured wash, onto which she collages some coloured paper, painting over the top to make it more permanent. Her choice of colours initially is often quite instinctive and non-specific. Opaque colour and collage on top of the transparent washes gives another layer much closer to the viewer. After working in this way for a while she began to use the shapes she saw in the bowl, using both watercolours and acrylics.

Some of the boundaries within the rectangle were established with strokes of oil pastel, which resisted subsequent applications of paint, and remained firmly in place. Laura enjoys the use of boundaries, giving her little 'areas' to work with, which create a strong compositional pattern within the rectangle.

**Roz's Lovely Wavy Bowl**
Laura Reiter

46 × 53 cm (18 × 21 in)
Watercolour and mixed media
on 300 gsm (140 lb) Not paper

**Moroccan Teapot**

**Laura Reiter**

61 × 46 cm (24 × 18 in)
Mixed media on 300 gsm
(140 lb) watercolour paper

To achieve this soft-textured look, Laura used soft chalk pastel over areas of opaque paint. The pastel sits on the surface and creates a soft veil of colour and texture.

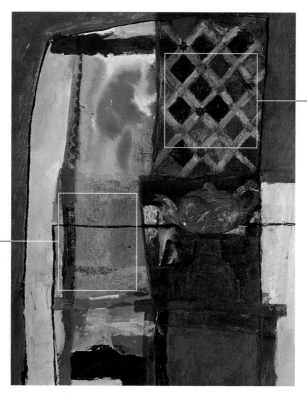

The 'old tiles' look of this corner of the painting was achieved with alternating layers of oil pastel and watercolour paint. The oil pastel resists the paint, but enough remains on the surface to give the impression of the old, worn look that the artist required.

## Artist's Secret

As a child, did you ever make stencil shapes from a potato? To create more permanent small, unique hand-made shapes for stencilling onto a painting, try carving the shape out of a rubber eraser. Use a sharp craft knife, being very careful of the fingers holding the eraser!

## Moroccan Teapot

Morocco has always fascinated Laura, and she visits the country as often as she can. Two vibrant, ancient cultures can be found in Morocco – Berber and Arab – and their cultural heritage can be seen and felt clearly today, particularly in the architecture to be found in the towns and villages. Moroccan architecture is particularly stunning, influenced strongly by Islam. The Muslim religion forbids animate representation, and therefore the ornamentation of the buildings reached a high level of decorative abstraction. Gold and silver were frowned upon, but lace-like patterns, and mosaic tiling were regularly used along with glasswork, Kufic script and stucco, and these elements are still very much in evidence today in well-kept buildings.

This image began with the colours of the fabrics Laura noticed on her travels and she researched further images of Moroccan artefacts and tiling patterns. If you enjoy travelling and painting the places you visit, take special note of the colours and patterns common to the place that are found in architecture, artefacts, fabrics and paint colours. This will enrich your response to the location and your paintings will reflect this knowledge.

# Ginger Jar

Laura had always loved this small ginger jar owned by her mother. She decided to use it for a painting and, gradually, as the picture developed around the shape of the jar, it began to have a Japanese 'feel' to it. The red table, with its tall legs, and the patterns at the base of the image have Japanese connotations.

The painting was built up slowly, and has many layers of colour. On the jar itself Laura used colour, a layer of gold and black ink, which she carved into. 'Layers' are important to Laura in many ways – the layers of the painting underpin and are part of the visual story and the act of building the painting with layers causes her to feel personally embedded into the image.

Laura does not use traditional compositional concepts consciously, but rather more depends on her instincts and a search for balance. She often looks for, and tries to create, a strong feeling of tension between spaces and shapes, and between figurative elements and abstract areas.

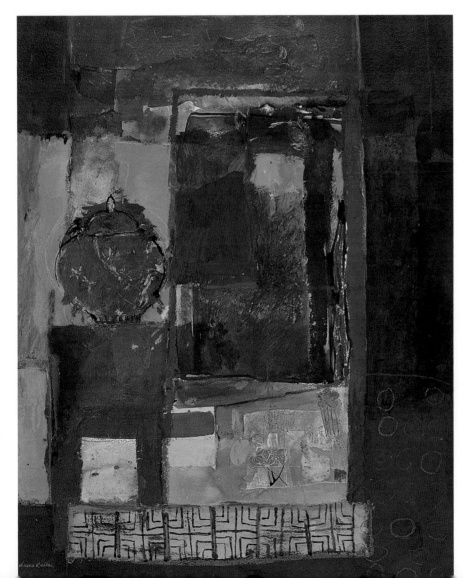

**Ginger Jar**
**Laura Reiter**
61 × 46 cm (24 × 18 in)
Mixed media on 300 gsm
(140 lb) watercolour paper

# Final thoughts

**'If I have seen further, it is by standing on the shoulders of giants.'**
Sir Isaac Newton (1642–1727)

I love this quote. It confirms, to me, the value of learning from others, and I hope that you will have learned a great deal by studying the work of the artists who have so generously contributed their paintings and drawings to this book.

There are those who scorn the teachings of others, and who maintain that we should simply look to ourselves and do what comes naturally. I, however, firmly believe that the artist who never looks closely at other artists' work will almost inevitably be somewhat limited in the way he, or she, approaches their own work.

We are all students, whatever our level of experience, and if we want to produce images that are rich, inventive, expressive and vital, we need to acknowledge and respect the discoveries made by others. We need to recognize that as our knowledge and understanding increases, the door to our own creativity and self-expression will open ever wider.

**Jackie Simmonds**

**Winter Morning,
Grand Canal, Venice**
Jackie Simmonds
29 × 39 cm (11 ½ × 15 ½ in)
Watercolour and collage on
watercolour board

# Taking it further

There is a wealth of further information available for artists, particularly if you have access to the internet. Listed below are just some of the organizations or resources that you might find useful to help you to develop your painting.

## Art Magazines

**The Artist**, Caxton House, 63/65 High Street, Tenterden, Kent TN30 6BD; tel: 01580 763673
www.theartistmagazine.co.uk

**Artists & Illustrators**, The Fitzpatrick Building, 188-194 York Way, London N7 9QR; tel: 020 7700 8500

**International Artist**, P. O. Box 4316, Braintree, Essex CM7 4QZ; tel: 01371 811345
www.artinthemaking.com

**Leisure Painter**, Caxton House, 63/65 High Street, Tenterden, Kent TN30 6BD; tel: 01580 763315
www.leisurepainter.co.uk

## Art Materials

**Daler-Rowney Ltd**, Bracknell, Berkshire RG12 8ST; tel: 01344 424621
www.daler-rowney.com

**Winsor & Newton**, Whitefriars Avenue, Wealdstone, Harrow, Middlesex HA3 5RH; tel: 020 8427 4343
www.winsornewton.com

**T. N. Lawrence & Son Ltd**, 208 Portland Road, Hove, West Sussex BN3 5QT
tel: 0845 644 3232 or 01273 260260
www.lawrence.co.uk

## Art Shows

**Artists & Illustrators Exhibition**, The Fitzpatrick Building, 188-194 York Way, London N7 9QR; tel: 020 7700 8500 (for information and venue details)

**Patchings Art, Craft & Design Festival**, Patchings Art Centre, Patchings Farm, Oxton Road, Calverton, Nottinghamshire NG14 6NU; tel: 0115 965 3479
www.patchingsartcentre.co.uk

**Affordable Art Fair**, The Affordable Art Fair Ltd, Unit 3 Heathmans Road, London SW6 4TJ; tel: 020 7371 8787

## Art Societies

**Federation of British Artists (including Royal Society of Painters in Water Colours)**, Mall Galleries, 17 Carlton House Terrace, London SW1Y 5BD; tel: 020 7930 6844
www.mallgalleries.org.uk

**Society for All Artists (SAA)**, P. O. Box 50, Newark, Nottinghamshire NG23 5GY; tel: 01949 844050
www.saa.co.uk

## Bookclubs for Artists

**Artists' Choice**, P. O. Box 3, Huntingdon, Cambridgeshire PE28 0QX; tel: 01832 710201
www.artists-choice.co.uk

**Painting for Pleasure**, Brunel House, Newton Abbot, Devon TQ12 4BR; tel: 0870 44221223

## Internet Resources

**Art Museum Network**: the official website of the world's leading art museums
www.amn.org

**Artcourses**: an easy way to find part-time classes, workshops and painting holidays
www.artcourses.co.uk

**The Arts Guild**: on-line bookclub devoted to books on the art world
www.artsguild.co.uk

**British Arts**: useful resource to help you to find information about all art-related matters
www.britisharts.co.uk

**British Library Net**: comprehensive A-Z resource including 24-hour virtual museum/gallery
www.britishlibrary.net/museums.html

**Galleryonthenet**: provides member artists with gallery space on the internet
www.galleryonthenet.org.uk

**Jackie Simmonds**: the author's website, with details of her paintings, limited-edition prints, books and videos
www.jackiesimmonds.com

**Jackson's Art Supplies**: on-line store and mail order company for art materials
www.jacksonsart.com

**Painters Online**: interactive art club run by The Artist's Publishing Company
www.painters-online.com

**WetCanvas!**: the largest community for visual artists on the internet, including Jackie Simmonds' own forum
www.wetcanvas.com

**WWW Virtual Library**: extensive information on galleries worldwide
www.comlab.ox.ac.uk/archive/other/museums/galleries.html

## Videos

**APV Films**, 6 Alexandra Square, Chipping Norton, Oxfordshire OX7 5HL; tel: 01608 641798
www.apvfilms.com

**Teaching Art**, P. O. Box 50, Newark, Nottinghamshire NG23 5GY; tel: 01949 844050
www.teachingart.com

## Further Reading

If you have enjoyed this book, why not have a look at other art instruction titles from Collins?

Bellamy, David, *Coastal Landscapes*
Gair, Angela, *Collins Artist's Manual*
Hodge, Susie, *How to Paint Like the Impressionists*
Jennings, Simon, *Collins Art Class*
   *Collins Artist's Colour Manual*
Lidzey, John, *Watercolour in Close-up*
Shepherd, David, *Painting with David Shepherd*
Simmonds, Jackie, *Collins Painting Workshop: Pastels*
   *Learn to Paint Gardens in Pastel*
   *Need to Know? Drawing & Sketching*
   *You Can Paint: Sketch*
Soan, Hazel, *African Watercolours*
Stevens, Margaret, *The Art of Botanical Painting*
Trevena, Shirley, *Taking Risks with Watercolour*

For further information about Collins books visit our website:
**www.collins.co.uk**

# Index

**Page numbers in bold refer to captions**